the
indoorartist

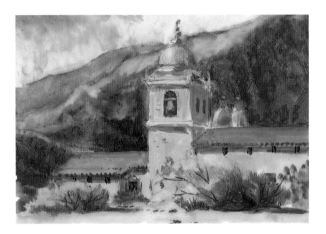

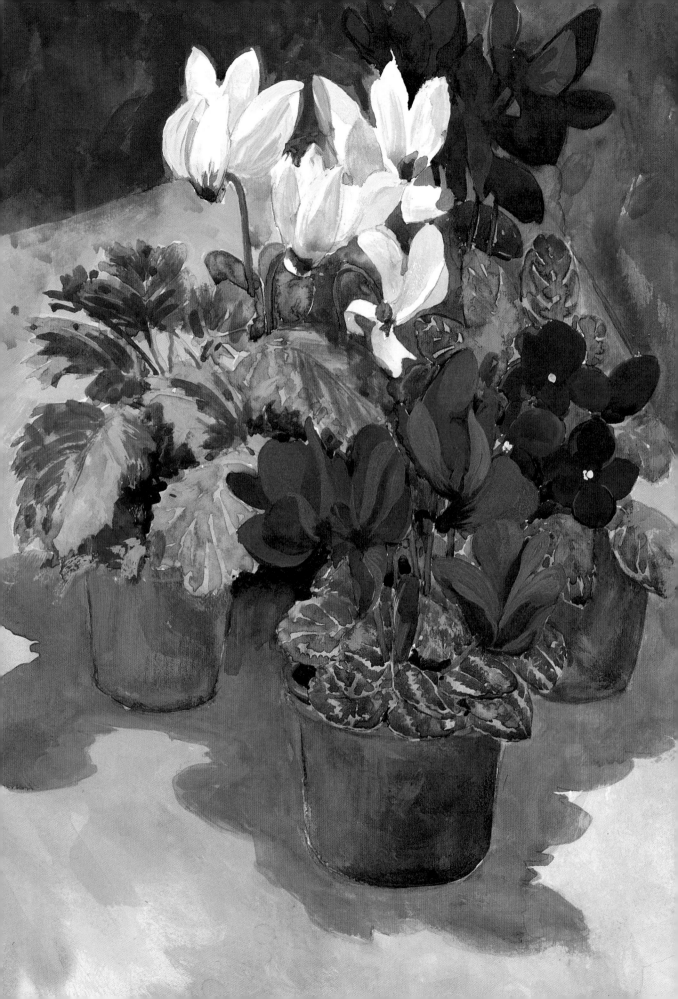

the
indoorartist

Watercolour ideas for painting at home

Linda Birch

*D*EDICATION
To my mother, Elizabeth Birch

ACKNOWLEDGEMENTS

Thanks to my husband, Trevor Pitt, for the critical advice and the coffees!
To my editor, Caroline Churton, with thanks for her guidance and patience.
Also to Karen Webb, who said I could do it!

First published in 2004 by
Collins, an imprint of
HarperCollins*Publishers*
77-85 Fulham Palace Road
Hammersmith, London W6 8 JB

The Collins website address is:
www.collins.co.uk

Collins is a registered trademark of HarperCollins Publishers Limited.

751.422
1465305 05 07 08 06 04
 2 4 6 5 3 1

A catalogue record for this book is available from the British Library

Editor: Diana Vowles
Designer: Anita Ruddell
Photographer: Syd Neville

The illustration on page 116 is reproduced courtesy of the Tate, London.

ISBN 0 00 715148 9

Colour reproduction by Colourscan, Singapore
Printed and bound by LEGO, S.p.A., Italy

ONTENTS

\mathcal{I}NTRODUCTION

This book came about as a result of my encountering many painters who cannot – or choose not to – paint outside 'in the field'. There are a variety of reasons for this: some live too far from the countryside or lack transport to reach it easily; some are discouraged by unreliable weather conditions; others are not in sufficiently robust health to undertake a trip to paint outside, while many women do not feel safe alone in isolated places.

If you are one of these artists who are not able to paint outside the home you probably feel frustrated and disappointed by your apparent lack of subject matter. However, being indoors can be a real advantage. Your home really is a place where you have the privacy and time to try out new things, hone your skills and find inspiration. I know there are some who maintain that you can only produce a real painting if you work al fresco. Not true! Until the 19th century, all artists painted indoors. Even Turner regarded his outdoor work as sketches meant for his eyes only, prior to painting his more finished work. While his sketches are sometimes prized above his

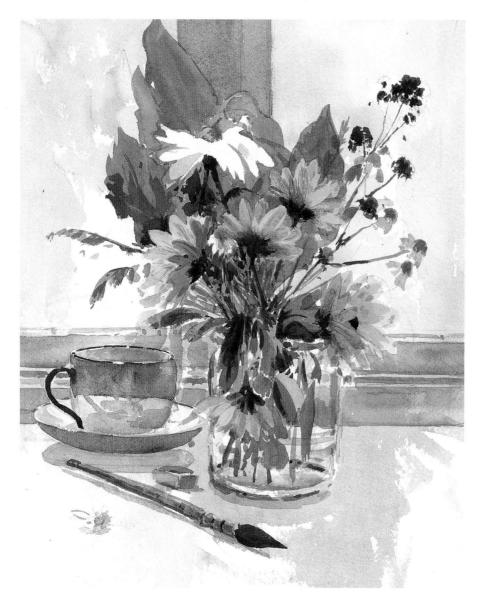

◄ **Indoor Flowers**
36×26 cm ($14 \times 10\frac{1}{4}$ in)

Being indoors provides an ideal opportunity to paint flowers and still life. It also gives you time to study form and colour at close range.

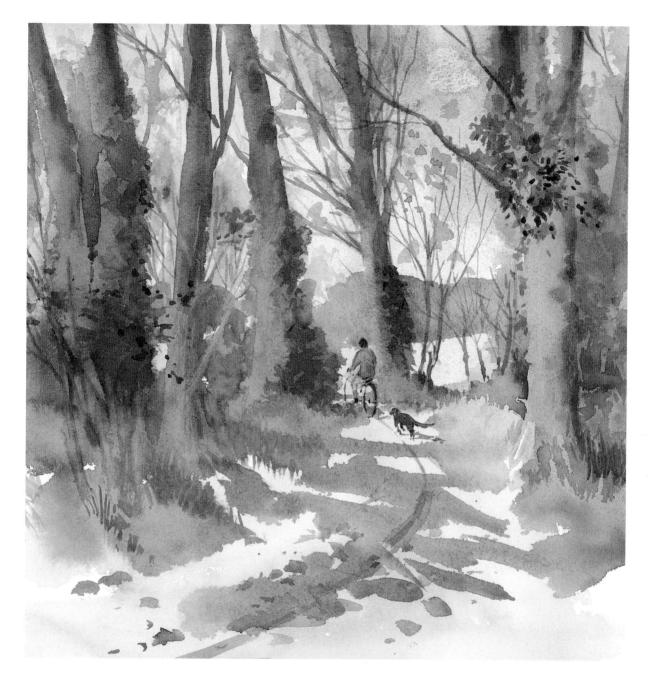

studio paintings, being indoors does not mean you necessarily lose freshness – it depends what and how you paint.

This is not a 'how to do it' book, since there are plenty of those already available if you need them. Instead, it is intended to act as a resource for ideas and inspiration if, for whatever reason, you are not able to go outdoors to paint. Although it deals predominantly with watercolour, the same ideas can be applied to whatever your medium happens to be. I hope you will find that they bring new life and energy to your painting.

▲ Country Path
27 × 27 cm (10½ × 10½ in)

Being inside doesn't have to stop you painting the outside! You can work from sketches or photographs, or even use props to re-create an outdoor scene.

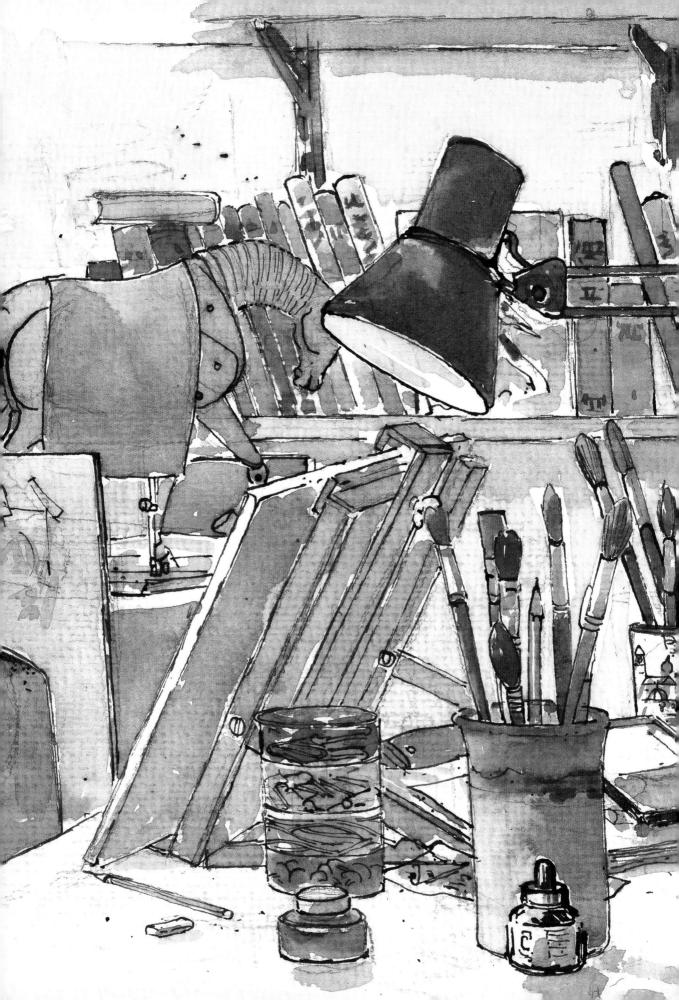

A PLACE OF YOUR OWN

Everyone who paints needs a place of their own to do it in. It is not easy if you need to clear the dining-room table every time you want to paint and then tidy your equipment away before the next meal. You must have a place to work, to think and to make a mess! Creativity is not a neat affair that can be set up and tidied away at the end.

You don't need a large studio for the purpose – a corner of a spare room and a large table will do, just so long as it is your place where you can be left alone to work out your creative ideas.

◄ **A Place to Work**
24 × 32 cm (9½ × 12½ in)

Every artist needs a permanent place to work with a desk, a chair and a lamp. Working materials can be left out ready to use – and to act as a subject, too.

ORGANIZING YOUR SPACE

Consider the options your home affords you for a dedicated work space. You may be fortunate enough to be able to take over a spare bedroom and turn that into your studio. However, if you have only the corner of that spare bedroom don't despair – there are many ways of combining living and working spaces today, and rooms are often dual-purpose.

You will need a worktable of some sort. This doesn't have to be a fancy affair, and if you are really short on funds you could consider buying a cheap wallpaper-pasting table from your local DIY store. They are large, practical and cheap, and fold away if you need to store them. One of these sufficed very well as my own first worktable.

Try to arrange your table near a window to catch the light, although the traditional north light is not really necessary. Even if you are working from a subject that needs a constant light direction, daylight bulbs, which can be easily obtained, will do the trick. I prefer to use a spotlight desk lamp to light my still-life groups or flowers. It gives warmth and vibrancy to the colours, whereas daylight bulbs are cooler in hue.

Make sure you have a comfortable chair to sit on while you work at your table. A typist's chair, which can be bought cheaply from suppliers of second-hand office furniture, will be useful for its adjustable height control, which is vital to avoid developing a bad back. When sitting for long periods I find a footrest useful, which in my case is simply an old box.

▼ *Having a place of your own with all that you need laid out in readiness will make it easier to take up your work when you have only a short time available.*

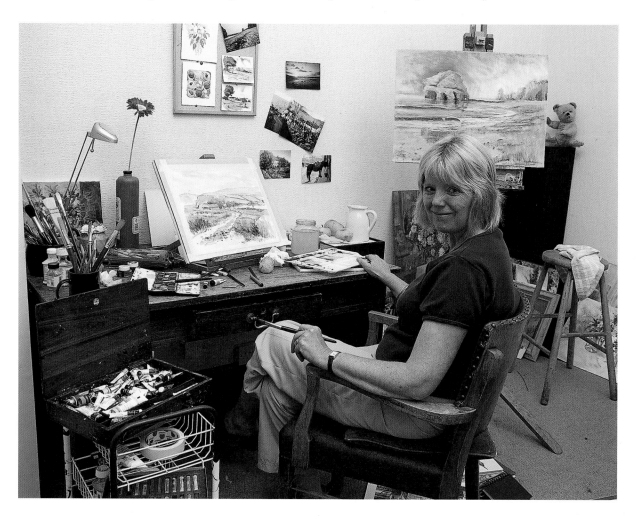

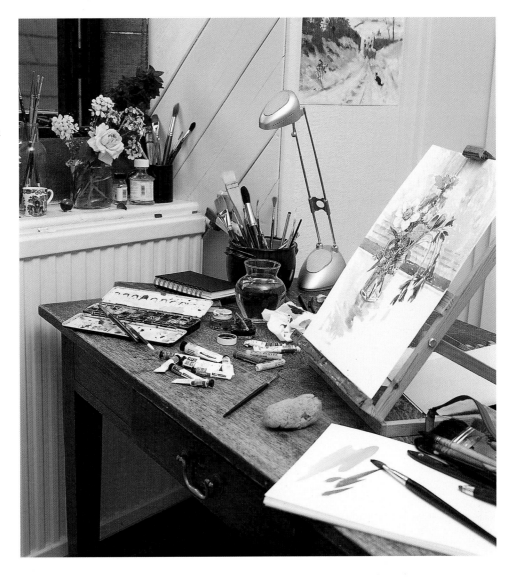

► *Try to position your table near a window to get the benefit of maximum natural light.*

Practical considerations

If you don't have any spare cupboard space, a small trolley with several baskets designed to hold vegetables makes good (and cheap) mobile storage. You can place sheets of paper under a spare bed to keep them flat and out of harm's way, and other items you need such as a water jar and inks, spare still-life material and books can be stored on an overhead shelf.

When you are working for long periods of time in one spot, you may need to provide extra warmth. If you only need to keep the specific area you are sitting in warm, consider using a safe form of heating such as an oil-filled radiator which is sealed and can be wheeled to where you want it. It is not advisable to use water in close proximity to electric fires, fan heaters and convectors.

Making space for your subject

When you want to paint a still life or botanical subject, you will need a small table as a base so that you can position it at a suitable distance away from you. If needs be, you can make it much larger by placing a broader sheet of board on top. To cut out distractions from the rest of the room, make a still life 'box' from a large empty carton. This will enable you to drape material behind and create light and shadow when the subject is lit by the spotlamp. Alternatively, a shelf placed just below eye level would also make a good site.

If all else fails, try putting the still life on the floor. I once painted a very successful group of tulips placed on a painted wooden floor. Looking down on the flowers meant I could see more of the flowers than the container, which worked well.

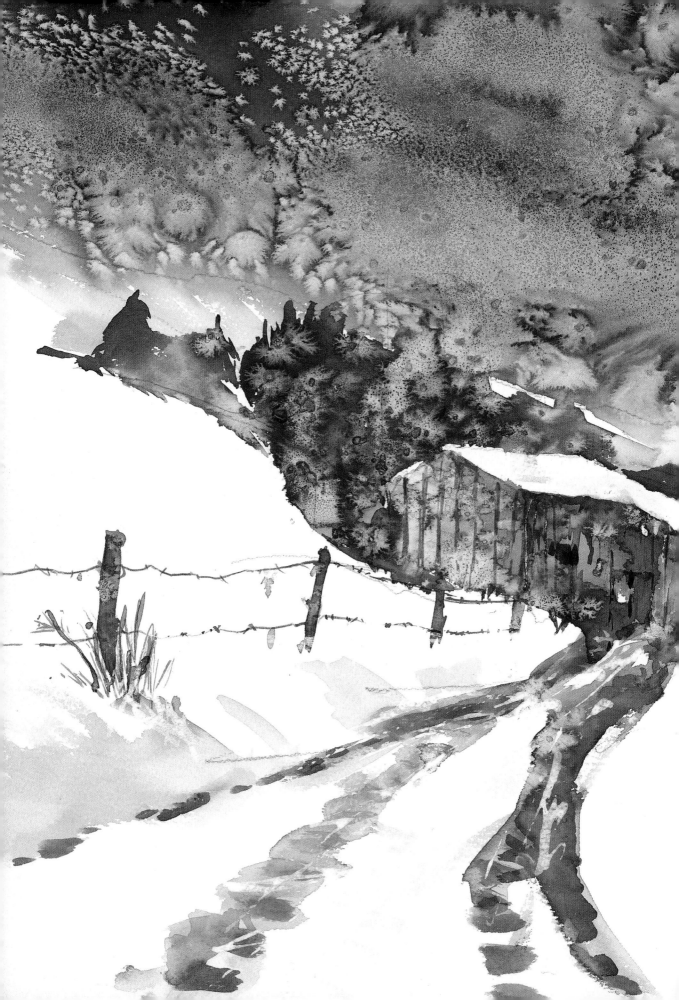

SELECTING THE RIGHT MEDIUM

Although this book is primarily about watercolour, there are other media that you can use with it. Gouache, an opaque form of watercolour, can be employed for its thicker, impasto quality, while inks give rich, subtle, transparent colour. Both of these can also be used on their own for picture-making. Media such as coloured pencils, pastels, charcoal, wax, salt, clingfilm and paper in the form of collage can all be added to watercolour, giving a variety of textures.

There are many other techniques you can try such as achieving texture with sponges, rough-textured hessian, watercolour sticks, oil pastels and indeed any other media or household items that catch your eye. Allow your imagination to run free, as you will learn even from experiments are not successful.

◀ **Barn in Snow**
38 × 56.5 cm (15 × 22¼ in)

Salt and inks were added to watercolour to create frost and starkness in this winter scene.

UNDERSTANDING DIFFERENT MEDIA

Watercolour

The transparent, fresh quality that watercolour possesses makes it ideal for using clear, apparently simple sweeps of colour and capturing the fleeting effects of light. It relies on the use of the paper surface shining through colour washes, and to convey the lightest areas the paper is usually left untouched. Dropping one colour into another (known as painting wet-into-wet) creates melting colour effects of great beauty and subtlety.

Watercolour can be used on specific watercolour papers with three different surfaces: Hot Pressed (HP), which is smooth; Not, a medium-textured surface; and Rough, which is heavily textured. However, it is also worth trying watercolour on stretched papers such as cartridge and pastel papers.

◄ *Only two pigments, Cobalt Blue and Burnt Sienna, have been used to create this tower. The feeling of strong light on the building has been conveyed by leaving the paper empty.*

Line and wash

Using pen and ink with watercolour will 'lift' your work and strengthen the colour as well as adding dark tones. To avoid an overworked look, keep the watercolour a little weaker than you would normally use it. Line can be used before painting (line and wash) or afterwards (wash and line).

Try using various types of pen to achieve different effects. For example, a felt-tip pen with a broad nib will produce strong, contrasting blocks of tone, while a fine-nibbed pen adds a more linear quality to your work. You can even use a garden twig, which yields characterful lines and marks. Make sure the ink is waterproof or it will run into the watercolour.

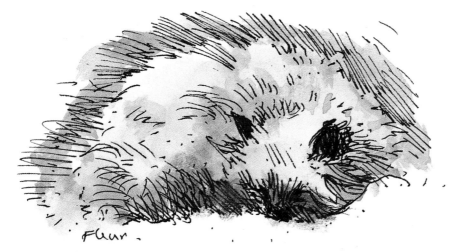

◄ *This study of a cat sleeping had to be made quickly, since animals will move when you least want them to. The drawing was made first and a wash of colour was added when the ink was dry.*

Gouache

Gouache is an opaque form of watercolour. It is normally worked from dark to lighter tones, using white to lighten colours. In the past it was employed to heighten the light areas of watercolours painted on tinted paper, and was described as 'body colour'. It was also often used to make small studies preliminary to a larger oil painting, since it can imitate the effects of oil paints.

The textured quality of watercolour paper is not necessary for gouache, and stretched cartridge paper or thin mounting card both make ideal surfaces for this medium. It can be combined with traditional watercolour, provided great care is taken not to destroy the integrity of the latter. Used on its own, gouache is a pleasant relief from the unforgiving nature of watercolour, in that it can be built up and altered in a way that would be impossible in a medium that relies on transparent washes.

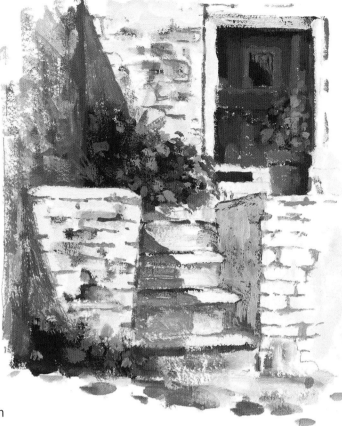

▲ *Gouache can be applied more thickly than traditional watercolour to produce texture. Here, dense, creamy white has been used to create the surfaces of wall and steps.*

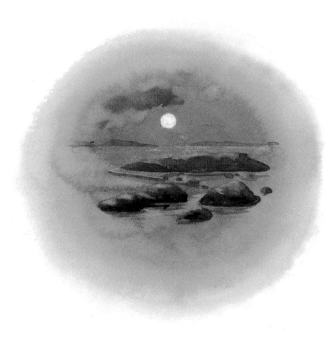

▼ *Drawing inks come in a rich range of colours. Here they have been used in transparent layers to create the soft glow of a setting sun.*

Inks

Inks are ideal companions for watercolour and their rich, vibrant colours make them exciting for the artist to work with. However, their benefits stretch beyond striking effects. Try using them to glaze a watercolour in order to restore colour balance; they can be mixed and applied in washes to create the subtlest of colours. Because they are waterproof when they are dry, luminous washes can be built up, with none of the muddiness that can afflict watercolour. Nevertheless, the finished result is identical to watercolour.

Most, but not all, drawing inks are waterproof, so it is worth checking the label before you buy. Acrylic inks are waterproof and are available in a sumptuous range of hues.

MIXING MEDIA

Coloured pencils

Coloured pencils and watercolour pencils are a useful addition to a watercolourist's toolbox. They are capable of astonishingly realistic effects when used by themselves; added to a dry watercolour they can restore texture and brighten or subdue tones without destroying the character of the paint. Try using them, for example, to add tree twigs or fine grasses to a painting.

Both types come in a large range of hues. Pick your own selection of colours rather than buying a box so that you do not waste money on colours you will not use. I find the best colours for adding to a watercolour are the tertiaries – greys, buffs and olive colours. Coloured pencils employed on top of a dry watercolour can even be removed with an eraser if unsuitable. If used wet, watercolour pencils are handy for small works, though they are limited in their ability to create large washes.

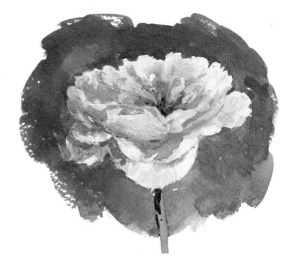

▲ *Pastel has been added to this flower in order to increase colour in its centre and create a more even tone in the background.*

Pastel

Pastel is good for achieving intensity of colour and for adding texture, but always remember to respect the character of watercolour. Once pastel is added, transparency will be lost, so use it only in areas where it will enhance the painting. However, there will be times when a watercolour will fail, despite all your efforts. Pastel can then be used on top of the painting in order to rescue it. The result will be a pastel painting and not a watercolour, but a painting will have been saved and transformed.

▼ *Coloured pencil has been added to this watercolour when dry to create texture on the walls of the barn and add grasses in the foreground. A little Ice Blue was rubbed into the background to soften the tone on the background hills.*

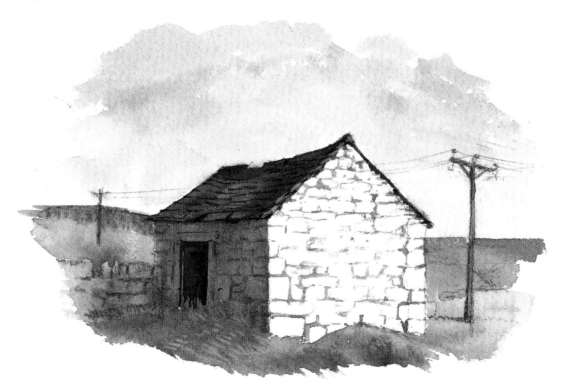

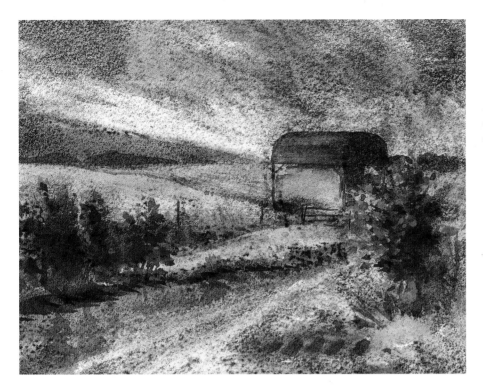

◄ *Here charcoal has been applied on top of a dry watercolour. An eraser has been used to lift out the light areas.*

Charcoal

Charcoal can be used over a dry watercolour, then rubbed back with an eraser and fingers to reveal an image. Its smudgy grey and black tones help create a feeling of mystery and atmosphere in a watercolour. You can even rescue a painting that has gone wrong by adding charcoal over the top and lifting it out to reveal the areas you choose.

Charcoal is easily smudged, so needs careful handling. It can be sprayed with fixative when complete. Wet watercolour and charcoal do not usually mix well unless you want to create a really sludgy effect – but try it and see. After all, there are no rules that cannot be broken in art.

Wax

Wax is very useful for adding texture or maintaining highlights in a painting. The accurate placing of the wax is important, so a birthday-cake candle makes a better choice of tool than a household candle. Once in place, the wax resists watercolour washes. Apply it before any paint if you want to leave the paper white. As most highlights are either warm or cool rather than true white,

the alternative is to add the wax over a light wash of colour, provided it is dry.

Candlewax is particularly good for grainy textures such as tree bark and stones. It can also be used to create sparkle on water. If you enjoy the effect of wax resist and watercolour, consider using oil pastels with watercolour to gain colour as well as texture.

▼ Here I dotted in some wax highlights over a light blue base, then applied mid-tone washes. I made more wax marks to create lowlights before adding the darkest tones.

USING HOUSEHOLD ITEMS

Salt

When added to a drying watercolour, salt produces surprising results. As the crystals dry they draw colour off the paper, resulting in an entirely random speckled effect. The technique most obviously lends itself to winter scenes, such as snow crystals and snowstorm effects. However, there are other places you can employ salt. Try using it to produce a mottled effect on old pieces of wood, or on leafy foregrounds in autumn landscapes. It will produce an interesting background to a still life, and dropped into an area of still water can render effects not possible with a brush. You will need to lay washes of quite deep colours to benefit from the qualities the salt will produce.

You can use table salt or coarse sea salt, which produces larger 'starbursts'. It is wise to experiment a little first, in order to discover the best time to drop salt onto a painting. Aim to do it a short time after you lay a wash, before it has had time to dry. Don't continue to add more paint after you have used salt.

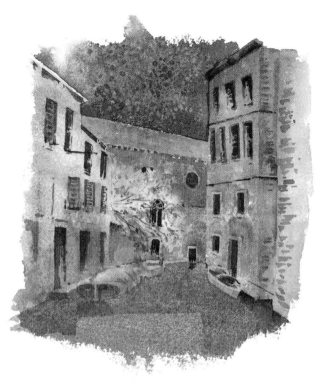

▲ *Here I dropped salt onto the sky and water areas as the painting dried. I used coarse sea salt, which produces a more starry effect, for the sky, while table salt was added to the water.*

It needs to be left flat in order to dry, which can take a couple of hours or even longer depending on the temperature of the room. Once it is dry, gently brush off any excess.

Soap

Adding soap to a painting creates a very different feel to the way the brush and paint behave. You need to use liquid soap or shampoo, and substitute it for water. This makes the paint sticky and creates defined brushmarks rather like painting in oils or acrylics. Bouncing the brush slightly in the soapy colour will produce bubbles. Use soap to achieve craggy textured effects.

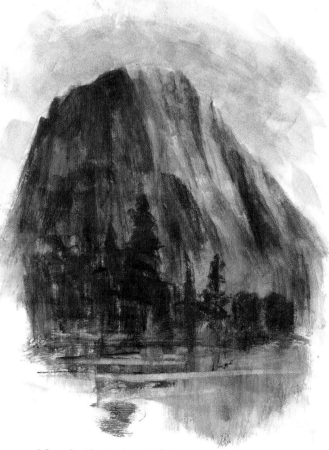

◀ *Soap used instead of water is good for rendering strongly textured subjects such as this mountain. The marks you produce will create an impasto result resembling oil paint.*

▶ *Here clingfilm was used to create ripples on a streambed, though the subject was decided on only after the clingfilm was removed. The stones were then picked out in watercolour.*

Clingfilm

Clingfilm laid on top of a wet watercolour produces some really interesting effects. Be prepared to accept what comes – the results are not easily controlled. I find it works best with linear forms such as tree bark, stems and the movement of water. It is a useful spur to the imagination – try experimenting with it to create fantasy landscapes.

To use clingfilm you need to lay some generous, strong washes of colour; water dropped and dribbled onto the wet colour will contribute to the result. Lay the clingfilm loosely over the area and press down gently, allowing the material to crease and wrinkle naturally. Leave flat to dry before lifting off the film to reveal the texturing. Watercolour can then be added to reinforce the chosen image.

Collage

Collage is an exciting addition to a watercolour. It produces highly unusual effects, mainly textures, that cannot be achieved any other way. You can add any material to your surface, tissue paper being a favourite of mine. Make an underpainting first, then tear small pieces

of tissue (the paper sizes don't matter, as long as the edges slightly overlap the next piece when stuck down). Stick them to the painting with paper glue. The image will still be visible underneath.

Once the tissue paper has adhered to the surface, paint over it with watercolours (or inks if you prefer). The paint will run beneath the pieces of tissue paper, creating a batik-like effect. When it is dry, the collage can be sealed with a paper varnish. This will tidy any stray pieces of tissue.

With this technique, be prepared not to be in control. The paint will wander wherever it will, but relying on serendipity and being open to adventure is a good thing sometimes when you are painting.

▶ *This red pepper was created with torn tissue collage and watercolour. The tissue was stuck in small overlapping pieces onto the paint. More colour was applied on top.*

TRYING DIFFERENT TOOLS

The list of tools you can use is endless. There are no right or wrong tools, just some that are better for the job in hand. Of the large number of products on the market, some are useful and others just gimmicks: do you really need to buy a cut-down painting knife for painting stonework when a cut credit card will do just as well? You can use many items found around the home that will create the effects you are seeking and also provide some surprises.

Varying your tools to achieve different effects can be very rewarding. You probably have the usual mop, round brush and small-detail brush for watercolour, but it is good to try some alternatives. I find twigs, credit cards, housepainting brushes, fabric, fingers and fingernails useful, and if you experiment with these you will discover a range of new marks to incorporate in your paintings.

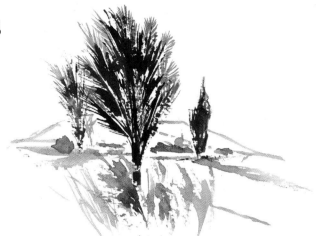

▲ *Cut up old credit cards to make painting tools. Here they have been used to make banana palms and foreground grasses.*

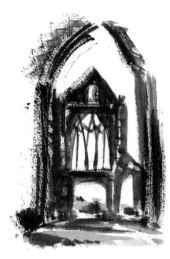

◀ *Twigs make wonderful pens, producing excellent free, characterful marks.*

◀ *An old household painting brush dipped in watercolour was used to create this ruined church.*

▼ *Coarse hessian dipped in watercolour made the choppy sea around the rocks.*

► *Fingerprints make good textural marks. Here they were used to describe the baby owl's fluffy down.*

▼ *A fingernail scraped through wet watercolour paint made the trunks of these trees.*

Silverpoint

Silverpoint was originally used in the 15th and 16th centuries, before the discovery of graphite. It produces very fine detail and makes an interesting change from normal pencil drawing.

It is quite easy to make your own silverpoint. You will need a piece of heavy-duty cartridge paper or watercolour paper; a tube of Chinese White watercolour or white gouache paint; and a silver coin, an item of jewellery, or a piece of silver wire.

Begin by covering the paper completely with a thin coat of white paint. When it is dry, paint again with a thick solution of white (historically, a little colour was sometimes added, which you can achieve by choosing a pigment from your watercolours).

When the second coat of paint is dry, draw into it with your piece of silver. Although the image cannot be rubbed out, moistening the area with a small damp brush will remove unwanted lines.

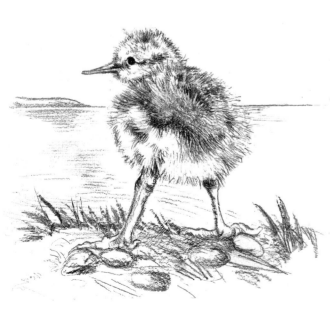

◄ *Silverpoint is particularly good for fine detail work, so I used it for this drawing of a little avocet chick to depict its fluffy down coat.*

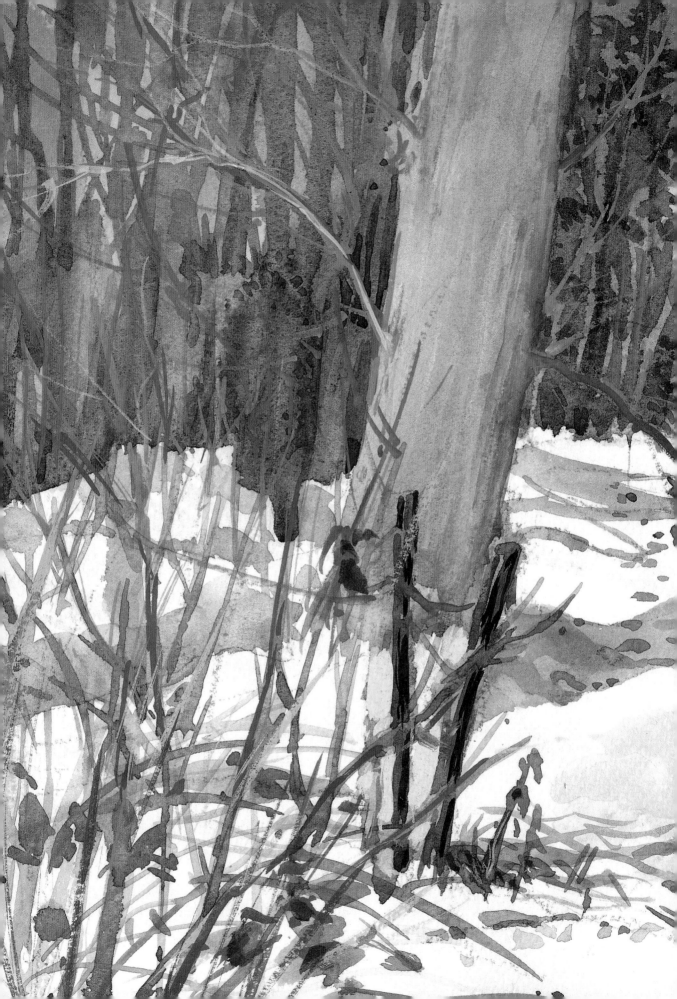

WORKING FROM YOUR PHOTOGRAPHS

Working from photographs is absolutely ideal for the indoor painter. Everything you might ever want to paint is available, from mice to mountains. Make use of your camera when you are out and about, picking subjects you know you will want to paint. Taking pictures of foregrounds, trees, domestic and wild animals, groups of people and skies will soon give you a bulging reference file of your favourite things.

 You are not limited to your own pictures, of course – we live in a highly visual age and magazines, newspapers, television programmes, videos and the Internet all present us with dozens of images to inspire us every day.

◄ Snowy Wood
22 × 29 cm (8¾ × 11½ in)

For this watercolour painting I used a photograph as reference. I modified the composition and added more colour than the photograph depicted.

INTERPRETING PHOTOGRAPHS

Don't be put off by purists who decry the use of photographs as subject matter. Dégas, Cézanne and Sickert were just three of the many painters who have used photographs as reference, so there is no reason why you should not do so.

However, the purists do have a point. The use of photographs has its pitfalls and you need to be aware of them. Colour and tone can be distorted, as well as shape and size. You must also interpret a photograph as a painting rather than just making a straight copy.

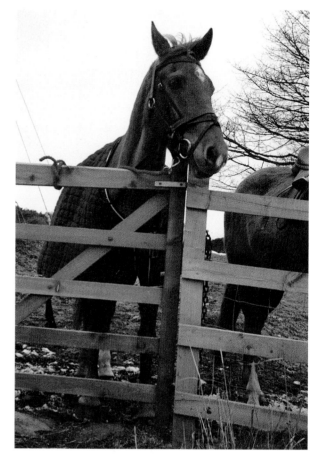

▶ *In the photograph on the right the horse's head appears too large for the body.*

▶ *To correct the problem, I have drawn the body larger to adjust the scale.*

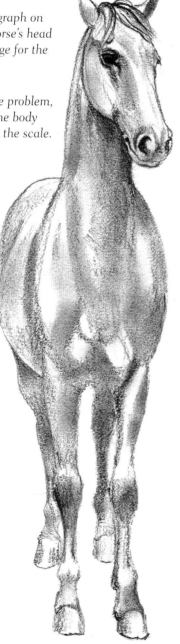

Remember always that you are commenting in a pictorial language on what you find beautiful, interesting, dramatic or even horrifying. In the case of shots that have been taken by professional photographers, you also need to make your own interpretation in order to avoid breaking the laws of copyright that protect their images from unauthorized reproduction.

Problems of scale

It is said that the camera cannot lie, but it certainly can. Distortion of size is a common problem. Objects that are nearer the camera can appear much too large and out of scale. Depending upon the lens that the photographer has used, distance can be lengthened or shortened. A long lens, for example, can make a mountain appear to rise directly behind a house when in fact the slopes may be a mile away, while a wide-angle lens will make your garden look twice its length.

Colour and tone

Both colour and tone may be reproduced falsely in a photograph. Many artists work from transparency film because of its greater accuracy in this respect, but it is less forgiving of inaccurate exposure than print film and is thus better avoided unless you are good with a camera. Also, the colour values do vary quite widely between one type of film and another, so if you are taking the photograph yourself, always make colour notes of what you can actually see.

This becomes particularly important in the case of shadows. The lens will see all shadows as black, while the eye is able to discern a range of colours in the dark area. The camera's problem with reproducing extreme degrees of contrast becomes particularly apparent with a subject such as a sunset. The camera's light meter reads the scene as one full of light with the result that the darker land below is rendered black in the photograph, though it is seen by the human eye as being softer, more subtle tones of dark grey. Try putting a piece of black paper near the horizon of the next sunset you can view from your window, and you will see what the tones should be.

▶ *The photograph of a sunset shows how the horizon is read by the camera as black.*

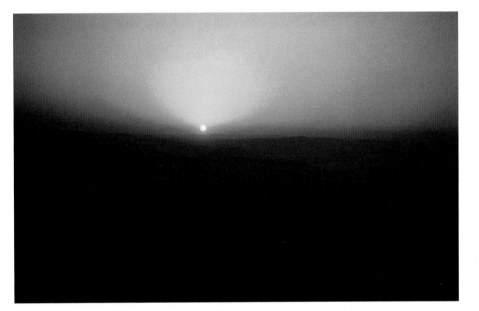

▶ *In the painting the tones have been corrected to those that the eye can see.*

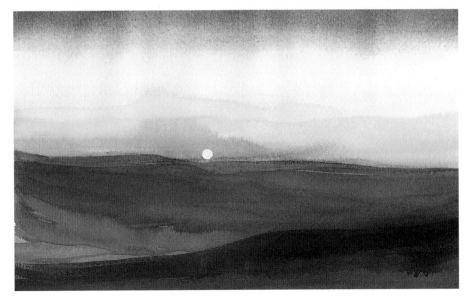

USING BLACK AND WHITE PHOTOGRAPHS

Black and white photographs offer exciting opportunities to the painter. Their tonal range appears wider than colour photographs and therefore more accurate, although the modern black and white photographic print still cannot reproduce the subtleties of tone that can be seen by the human eye.

The most easily accessible source of black and white photographs these days is your daily newspaper. Landscapes and interesting animal studies are of immediate appeal, but your painting does not have to be confined to the beautiful or cute. If you feel strongly about the devastation of war, or the plight of a famine-stricken society, for example, why not say it in a painting? Art is a language as much as is speech. The Spanish painter Goya (1746–1828) painted and etched the horrors of conflict in an effort to express the appalling savagery of the Napoleonic invasion of Spain, while Picasso's *Guernica* was his response to the bombing of that town during the Spanish Civil War.

Working in colour from black and white

Using black and white photographs for reference does not necessarily mean you have to paint in monochrome; you have exciting creative

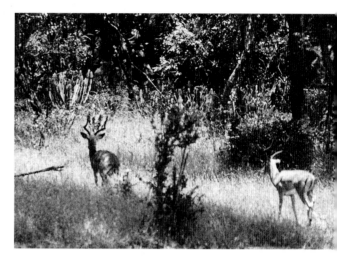

▲ *I decided that this black and white photograph of impala would be a good basis for a painting.*

opportunities here to explore colour themes of your own choice. You will find that the tones in the photograph are easier to see without the confusion of colour distracting your eye, allowing you to establish the tonal balance in your initial composition even before you decide which colours you are going to use. The lack of colour in your reference material

▼ *The monochromatic study of the photograph renders good tonal information.*

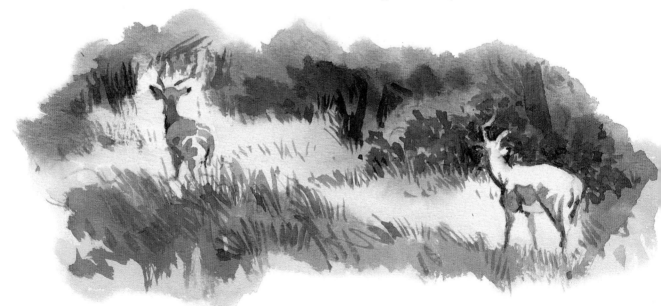

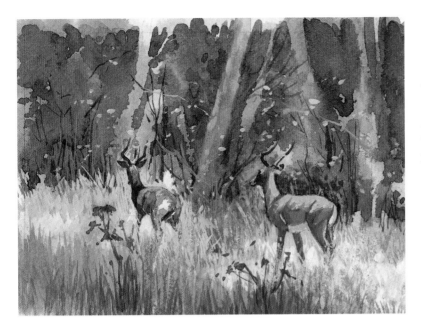

◄ Zimbabwe Impala
15 × 19 cm (6 × 7½ in)

Here the tonal information has been translated into colour for the finished painting.

will also release you from any preconceived idea of which pigments you should choose and make it a smaller and easier step to depart from a strictly representational approach.

Grisaille

A grisaille is a painting executed entirely in a range of tones from black through grey to white. The technique has a long history and was used originally by oil painters to lay in a tonal ground to a painting. John Cozens (1752–97), one of the great English watercolourists, is said to have adapted this method from oil painting and used it in his watercolours.

Grisaille's great advantage over traditional watercolour method is that the tones are painted first. Colour is then added in washes over the dry tonal ground. Creating tone and colour together is quite a difficult task, and using the grisaille method avoids this problem and is also a fascinating way of working.

You can adapt a grisaille to a watercolour by painting a tonal ground first, using any colour besides black, as long as it is capable of a range of tones from dark to light. If you are wary of the underlying colour being disturbed as you wash more colour on top, try using waterproof ink as your base tonal colour. You can also use acrylic paint to create the base, diluting the colour with water to obtain lighter tones.

► *This windmill was painted using a grisaille method. I laid in a tonal ground using sepia ink diluted with water to make a range of tones from near black to white. Watercolour was then glazed over the tones to add colour. The left side of the painting below the sky has been left uncoloured to show the tones used.*

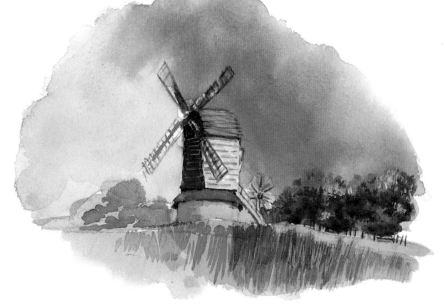

WORKING FROM TELEVISION

Working from television to improve your drawing skills is enormously useful. A good way to learn to capture movement is by sketching sporting events; try drawing from the next tennis or football match that you watch. Horse racing is another area you might like to explore.

Spend time watching your subject before you draw. See if you can pinpoint a particular movement you want to catch, then pick up a large sheet of drawing paper and start to draw – fast, as this way you won't have time to think or become nervous. When the figure changes position, start another drawing. Work on until your sheet is filled with half-finished studies. Eventually a figure will return to the first position you drew, then another, and so on. You should then be able to complete each or most of the studies. Working like this will give you not only practice in capturing movement but also studies of figures that can be used later in a painting.

Working from a video

Working from a video is even more useful, since you can 'freeze' movement in order to study and draw it. You can even draw over the forms on the screen with tracing paper. I did this once when I needed reference for a coach and horses for a book I was illustrating.

▲ *I had a lot of fun drawing a sumo wrestling match on television. The two giant figures were a fantastic mass of curves and folds as they struggled with each other.*

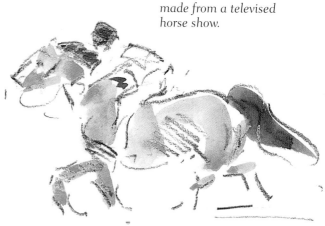

▼ *These sketches were made from a televised horse show.*

There are many videos available on the subject of wildlife. Use them to further your knowledge of animal anatomy and as direct reference sources for paintings. The Internet is also a good source of reference for almost anything you need.

▶ *I made several sketches from a video about bears with the idea of using them for a painting.*

▼ *I adapted one of my sketches into a composition using gouache and watercolour, incorporating a background from another source.*

PROJECT

PAINT A PICTURE FROM A VIDEO

- Adapt a landscape from a video. It can be any scene that appeals to you, whether mountain, desert, forest or rolling meadows.
- Make a painting of people or animals from another source, choosing subjects that will not look out of place in your landscape.
- Now combine elements of both paintings, setting the animals or figures within the landscape. Adaptations like this will prevent straightforward copying and help you decide what it is you wish to say in your painting when you plan its composition.

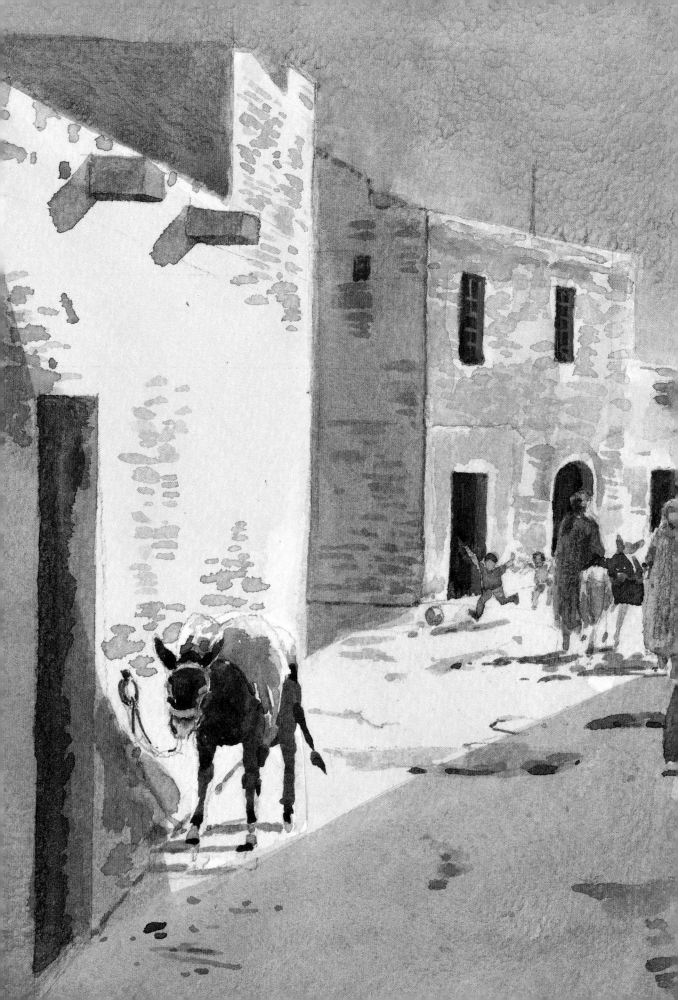

LOOKING AT SHAPE AND FORM

The three-dimensional form that makes a painting convincing is created by light and shadow, depicted as tone and colour. Simplifying objects to geometrical shapes and studying the way the light falls upon them will help you to render their structure and volume, while varying the source and strength of lighting in a painting will create very different atmospheres and moods.

Shadows are a vital part of picture-making, and they don't have to be grey. Awareness of the colour in shadows is important, and easy once you understand some simple colour theory. Equally important is considering the shapes between the objects, which play just as large a role in the composition as the objects themselves.

◀ **Middle East Street**
20 × 30 cm (8 × 12 in)

The strong sunlight of this Middle Eastern scene causes dark shadows which help to link the composition together.

UNDERSTANDING FORM

By simplifying objects to basic geometric shapes you can more easily observe the effects of light and shadow that describe the volume of their form. Almost anything can be reduced to a sphere, a cone, a cylinder or a cube. Once you look for these elemental shapes, you will be able to tackle even the most complicated forms with confidence.

Using shapes together

Once you have accustomed yourself to seeing objects as geometric shapes, you can easily add them together. Try reducing a tree to a simple sphere sitting on a tube, for example; this is the basic structure and volume of most trees, especially when they are in full leaf. Simplifying the form will help you to realize the volume a tree possesses. Within its outer spherical shape are numbers of smaller round shapes, which become the foliage masses. Shapes will obviously vary with the type of tree, but if you are aware of this basic underlying form it will help you paint trees and foliage more successfully.

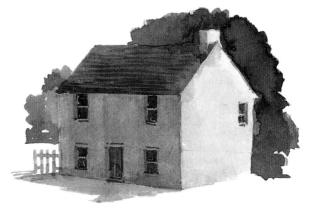

▶ *A cube: a house*

▲ *A sphere: a rose*

These elemental forms will help you construct more complicated drawings.

▼ *A cone: a seated dog*

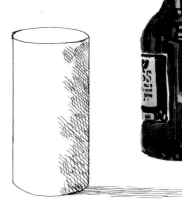

▼ *A cylinder: a bottle*

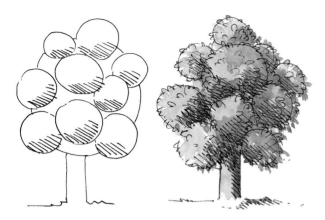

◄ *Although trees can be seen as spheres, their foliage masses also make smaller spheres within the main outer shape. This will help you understand how to render light and shadow on a tree.*

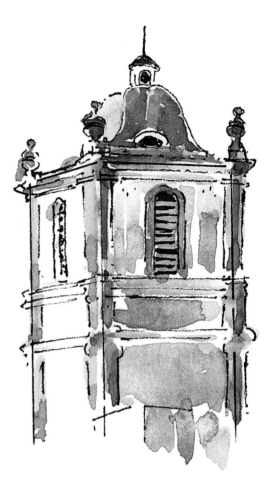

Analysing complicated shapes

Basic geometric forms are a good way to understand complicated subjects such as decorated architecture. Start with a cube or box shape, and build on from there. Keeping the geometric shape in mind will help you realize where the light and shadow should lie and you will be able get right to the essence of the form, no matter how complicated it appears. You will then be able to add the decorative details with confidence.

Geometric shapes and the human form

The human form can be constructed much more easily if you are aware that it too can be reduced to simple geometric forms. For example, even though there are indentations where the eye sockets lie, and raised and flat areas of the cheekbones to be observed, the head is basically an egg-shaped sphere. Try adding shadow to the sphere and see how it helps to bring the form into three dimensions.

▲ *Even a complicated object such as this piece of architecture is basically a cube.*

▼ *The torso can be simplified to an elongated box-like form, while the arms and legs are tubes which narrow down to the extremities.*

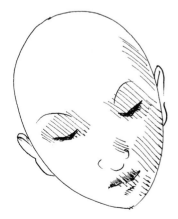

◄ *A spherical egg shape is a good starting point when drawing faces.*

CREATING FORM WITH LIGHT

To create the impression of light you need shadow, and the stronger the shadow the more intense the light will appear. By using shadows you can build a lit form with ease without even having to draw lines around it. To create the brightest light, simply leave the white paper untouched.

To prove this to yourself, find a photograph of a strongly lit subject – black and white photographs are particularly good for this purpose. Trace off only the shadowed areas. Transfer your tracing onto watercolour paper and paint the shapes black. You will discover that you can see the objects in the picture, defined only by their shadows; the eye makes up what it cannot see, if it is given enough information about the object that it can see. Now adapt this practice into your normal painting techniques using shadows of the appropriate tone and colour, leaving the light areas empty and 'seeing' only the shadow areas.

If you are working in sunlit conditions, you do not always have to leave white paper. Try laying a wash of Raw Sienna over the whole of the paper first, then put in your shadows when it is dry. This will increase the feeling of strong, warm light in the painting.

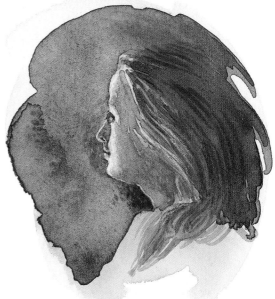

▲ *This face has been strongly lit from one side. The resulting deep shadows create a dramatic subject.*

Painting portraits with light

When you are painting portraits, light your subjects to provide maximum impact. Experiment with different lighting angles; illuminating a portrait subject in a particular way is your opportunity to say something about your subject. Strong lighting results in deep shadows that can create a sense of drama or mystery, adding to the character of the subject. Push your lighting to the extreme limits and try rendering the form in the deepest of shadow, so that only the highlights of the face are discernible.

▼ *In this sketch of a sunlit farmstead I have painted only the shadows in order to show how the eye 'sees' the shape of the buildings, leaving an impression of strong light.*

Making the most of shadows

There are many creative ways of using shadows to enhance your painting. Not only do they create solid-looking three-dimensional objects, they can strengthen the composition of your picture. It was not by chance that the Old Masters placed a strong foreground shadow in the front of their paintings. This device enabled the eye to be led into the painting more easily. Look at the paintings of Claude Lorraine (1600–42), for example, and you will see how effective is.

Shadows can also be employed to join elements of the composition, as in the painting of a street scene on pp. 30–1, where the shadows unite both sides of the street. These diagonal shadows help the eye to travel into the scene.

Shadows do not have to be duller versions of an object's colour, with just black or Payne's Grey added to the mix. Try making your shadows interesting and more colourful. One theory is that every shadow is made from three colours: local colour, that is, the colour of the object that the shadow is present on – for example, a red tomato would have red as its local colour; blue, which recedes (in particular French Ultramarine or Cobalt Blue), and helps 'turn'

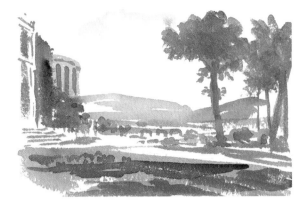

▲ In my sketch of a landscape by Claude Lorraine, foreground shadows lead the eye into the picture.

the form away from the light; and a little of the object's complementary colour, in the case of a tomato the colour being green.

In practice, this means that you check every shadowed surface in order to calculate its shadow colour. With primary colours such as red, yellow and blue, you need only go to their complementaries: for yellow it would be purple, for blue it would be orange and for red it would be green. Shadows on a buff-coloured path, for example, or a grey road, require more thought. Study your buff colour and try to work out which primary it favours most: blue, yellow or red? It could be yellow, so shadows thrown across it would be a purple-grey (a combination of buff, blue and purple). If the road is a blue-grey, the shadow will need a little orange added to blue and blue-grey.

▲ A shadow on a tomato containing red, blue and green.

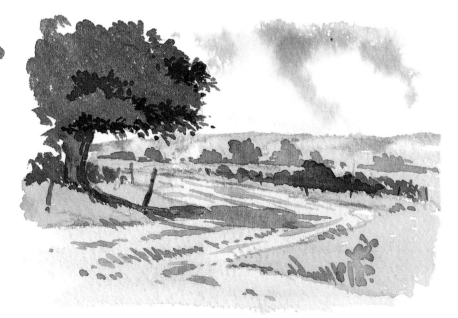

▶ Path and roadway shadows based on the closest primary colour.

DIFFERENT LIGHT DIRECTIONS

You can create very different moods by your choice of lighting. To show bright sunlight, make your shadows as dark as possible, so that there is a strong contrast between light and dark. This technique will make the images very three-dimensional and therefore solid and real.

For a change, try painting the light coming from behind your subject. This is known as *contre-jour* lighting and makes striking pictures. The subjects are rimmed with light, and the shadows are soft and subtle in colour and thrown forwards. Take great care when drawing shadows: they should be attached to the object and distinct in outline.

Make sure also that the perspective of your shadows is correctly drawn. Shadows thrown from a figure onto flat ground will appear narrower than the figure, depending on the angle at which it is seen. If a figure is standing near a wall, the shadow will be thrown onto the ground and also angled up the wall; if the ground that the figure stands on is uneven, then the shadow will undulate also.

The absence of direct lighting means there will be no shadows and the scene can easily appear flat, so unless you are skilled in handling tone, I would not advise painting a picture of this type. However, in misty conditions, where there is very little light and objects are softened and made indistinct, there is the opportunity to explore atmosphere and a sense of mystery.

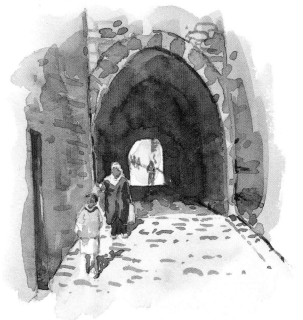

▲ *Bright light and strong shadows create the feeling of a hot, sunny day.*

▼ *Contre-jour lighting produces unusual atmospheric colours and tones. Figures in front are tipped with light coming from behind.*

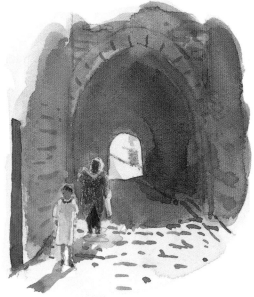

▼ *Low or indirect light also creates atmosphere.*

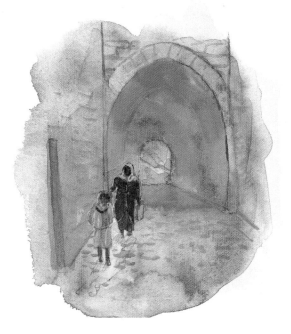

USING NEGATIVE SPACE

The spaces between the elements of a picture – the negative spaces – are often ignored, but they are as important as the objects themselves. They comprise a major part of any composition and should be considered carefully.

Assemble a group of objects, for example a bunch of keys or some brushes and pencils. Place them inside a drawn rectangle or square, arranging them so that they touch the edges of the square where possible. Draw the spaces around them and your objects will appear.

It takes a while to accustom yourself to seeing these negative shapes between the objects rather than the objects themselves. However, considering the shapes in your painting will help you to achieve a better composition.

▶ *In this watercolour of magpies I used negative space drawing of the white between their wings.*

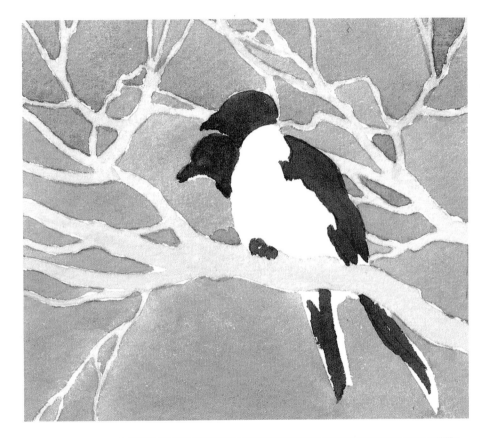

PROJECT

EXPLORING NEGATIVE SPACE

- Try making a negative space painting to make you more aware of the importance of shapes in your painting.
- Trace the negative spaces in a photograph or your own drawing of a group of objects.
- Transfer the traced spaces onto a piece of paper and then paint in the relevant colours that appear between the subject matter of your composition.
- If you find it difficult to see the negative shapes, turn your reference upside down so that your eye will perceive only shapes rather than recognizable objects.

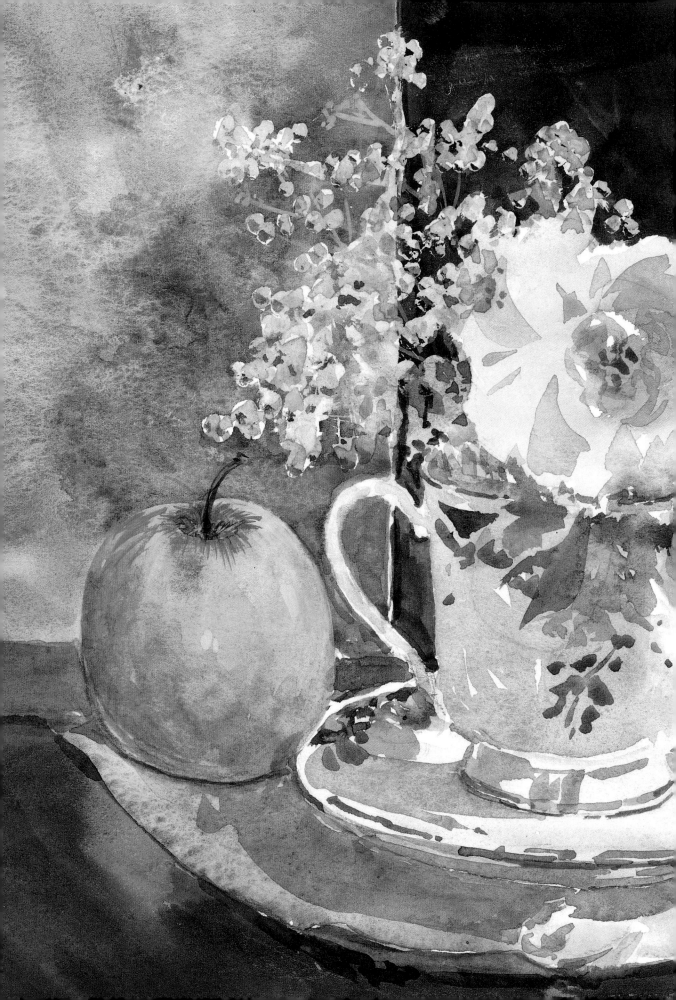

PAINTING STILL LIFE

When I was younger I regarded still life as dead life; the conventional set-up of fruit, drapery and a wine bottle did not stimulate my creative senses. I now realize that still lifes can be exciting and unconventional, depending upon what you choose to assemble in your composition and where you set it. They give you the chance to study and explore a subject at some length, and you are totally in control of what that subject consists of.

A still life can be made from any objects you choose. It can combine flowers, fruit, food, china, glass and fabric, for example – and I once even included a live cat by bribing it with cat biscuits to sit among lemons and apples.

◄ Roses and an Apple
24 × 33 cm (9½ × 13 in)

In this watercolour still life the apple and the flowers were chosen for their muted complementary colours of green and pink.

CONVENTIONAL SET-UPS

Composing a still-life group can be hard, but your instinct is a good guide – if it 'feels right' it probably is. Arrange the items then stand back and look at them, half-closing your eyes to eliminate unnecessary details. Study the group reflected in a mirror to help you judge the balance of the composition.

A method that always produces a good composition is to place the group so that, viewed from your painting position, all the objects touch. Another convention is to create a triangular arrangement, so the tallest object in the group stands above the rest, and they descend in front or to the sides of it.

Check the light direction in your still life. Shadows can be used to link the parts of the composition; they are the integral part of any painting. A spotlight will give maximum impact of light and shadow.

Changing your viewpoint

Look too for unusual viewpoints. Try painting your still life from above by putting the objects on the floor. Alternatively, placing the still life a little above your eye line, for example on a shelf or a windowsill, makes the composition much more challenging to paint and creates an unusual arrangement.

▲ *Arranging the objects so they touch each other makes a harmonious group.*

Looking for informal still-life groups in everyday life sharpens your visual awareness. Check out objects left lying on a table or counter top. From a standing position they will mostly be below your eye line, and that often makes them an interesting subject.

▼ **Breakfast Table**
32 × 48 cm (12½ × 19 in)

I look for table 'arrangements' after a meal, and that is how I found this subject. My viewpoint was from above, so I painted 'into the corner' of the table to create a triangular composition.

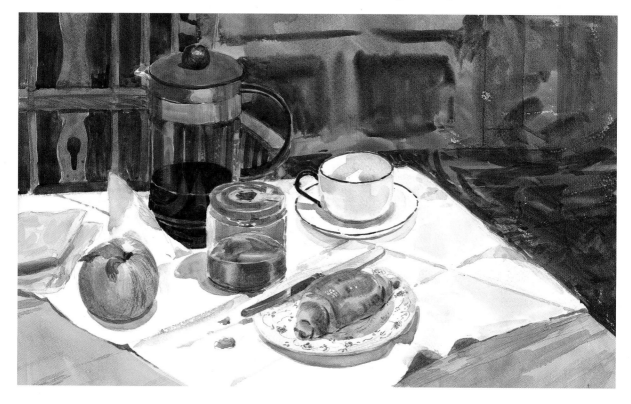

USING PATTERN AS A SUBJECT

Patterned still life makes a fascinating subject to paint. Try a still life made from elements such as decorated china and patterned fabric. Patterned light too can be employed – for example, venetian blinds throw shafts of light and shade, so objects caught in them are seen in a new way. The French artist Jean Édouard Vuillard (1868–1940) delighted in the pattern created by light and shadow in particular. These 'speckled' paintings evoke movement and atmosphere in the everyday world he painted.

Pattern repeats itself in line or tone or colour and can create various moods and levels of energy. A vigorous combining of curved and twisting shapes together with bright colours will make your still life exciting and energized, for example. Strong, warm colours such as reds and yellows will produce sumptuous and vibrant works. If you use colours from the cool range of the colour spectrum, for example blues, purples and cool greens, together with various shades of grey, then the painting will be calm, mysterious and reflective.

Adding other media to your watercolours will create different effects when you are working with pattern. Inks are a useful medium in this context, either used as line to increase the emphasis of the pattern elements or glazed over the watercolour for vivid colour.

▲ Staffordshire Blue
21 × 15 cm (8 × 6 in)

Blue-patterned china together with patterned fabric creates cool rhythms. I added the orange seed head as a complementary spark of colour. It was glazed with coloured drawing inks for maximum colour impact.

Formal repeat patterns

Formal repeat patterns are interesting to paint. Cluster identical objects together so that they make a pattern as a group, rather like a mosaic. You could do this with small iced cakes, dominoes, dice, reels of cotton, paint pans or even dried beans. You don't need to have large numbers of these as you can just repeat one or two.

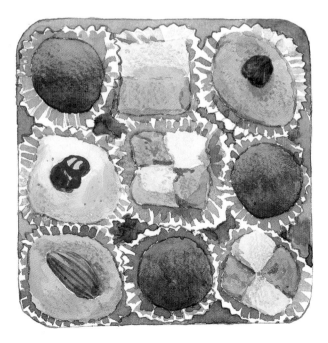

◄ Petits Fours
11 × 10.5 cm (4½ × 4 in)

Repeat patterns of pinks, yellows and browns in these small cakes of marzipan make a colour mosaic.

UNUSUAL STILL-LIFE SUBJECTS

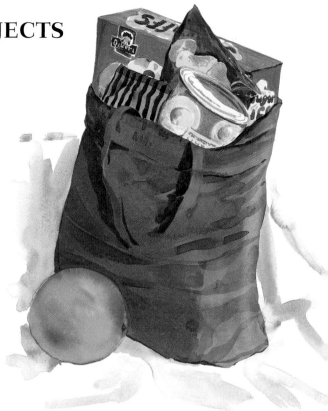

Sometimes I get bored with the same still-life subjects, so I need to go looking for the unusual to make me want to paint again. Search for the unexpected whenever you are feeling stale, as finding new subject matter is wonderfully restorative.

To take this fresh look, just think of some everyday things you might never have considered for a still-life group – for example, cleaning materials, a collection of stationery supplies, bottles of bathroom toiletries or the contents of the first aid box. Even something as mundane as a shopping bag full of groceries will offer a range of interesting colours, patterns and shapes and it's easy to tweak the arrangement of the contents to make the best of the composition.

Colour themes

Choose objects in different versions of the same colour; a colour theme nearly always results in an interesting painting. White is fascinating, since the subtlety of the relationship between shadow greys and creamy highlights is challenging and exciting. Try using various shades of red or blue for stunning effects, and perhaps follow that with a still life where just two colours dominate. If the colours are related the painting usually hangs together well.

▲ **Shopping Bag**
27 × 22 cm (10½ × 8½ in)

I added bright groceries to spill out of the top of this vibrant red shopping bag. I arranged a green packet on the top because it is the complementary colour of red and therefore produces a strong visual colour effect.

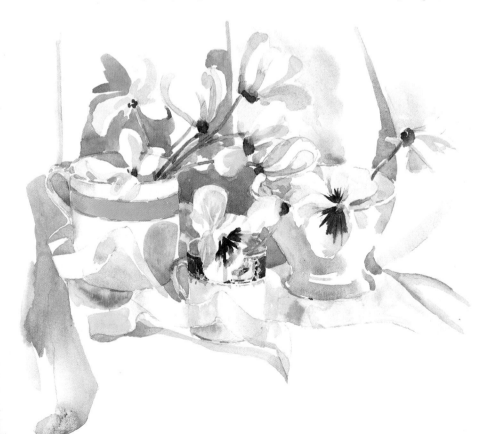

◀ **Flowers on the Table**
20.5 × 23 cm (8 × 9 in)

This still life was set in strong lighting conditions, which gave a good range of light and shadow colours. The pinks are all blue-pinks, which helps them to relate to the purple-blue of the pansies.

MEMORIES

A still life of objects found in the attic is generally full of memories and emotions. The history these things possess lends a lot of meaning to your painting, and you may find that the work turns out particularly well because you will feel fully involved in its creation.

Our memories are very selective. You might start by recalling colours and textures of things from long ago to waken your sensory memories. I remember taking particular pleasure in playing with coloured ribbons, and clearly recall the gorgeous blue silk dress of the antique doll I was never allowed to touch. Working on a tinted paper will add to the feeling of the past.

▼ *Old letters and a brooch bring me special memories of my parents and grandmother.*

▶ Attic Memories
23 × 34 cm (9 × 13½ in)

This painting shows toys from my childhood with pictures of my parents in their younger days. To increase the feeling of times gone by I painted on brown paper.

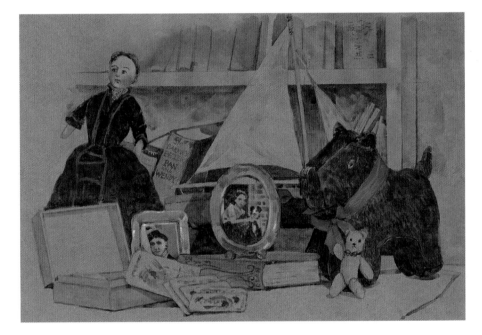

PROJECT

TIMES PAST

- Try raiding your attic for a still life of memorabilia, gathering a collection of objects that will work well together in shape and scale.
- Choose special childhood memories, possibly objects from past Christmases or old sports gear, toys, books and cards, perhaps with some fading photographs.
- Arrange your items into an interesting composition. Before you start to paint, consider which media you would like to use to help you evoke an atmosphere of the past and of old, crumpled textures. Be adventurous in your choice of paper, too.

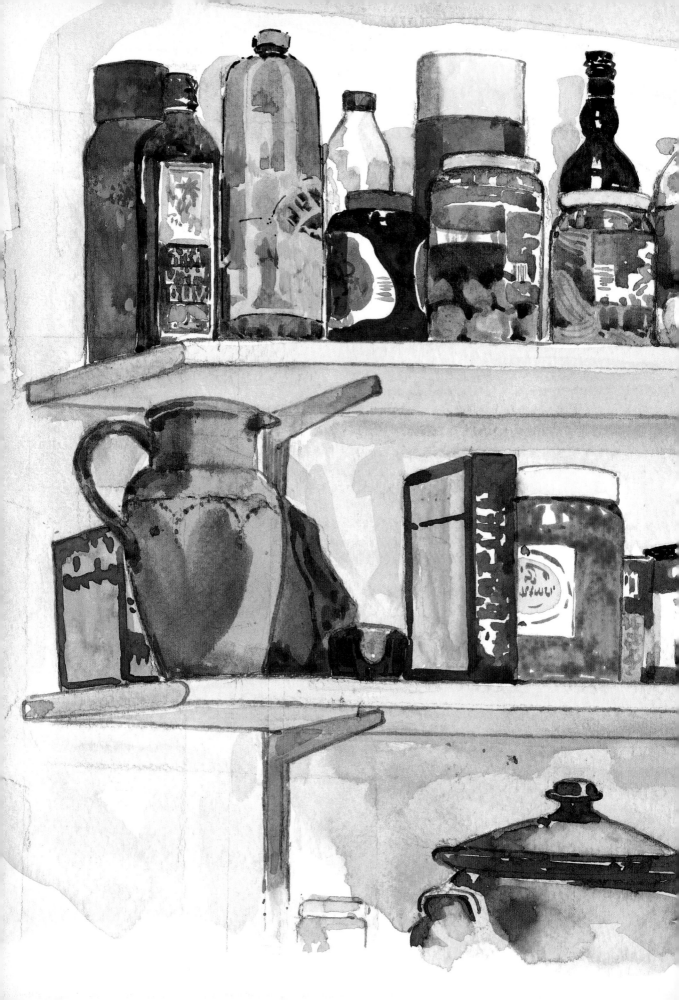

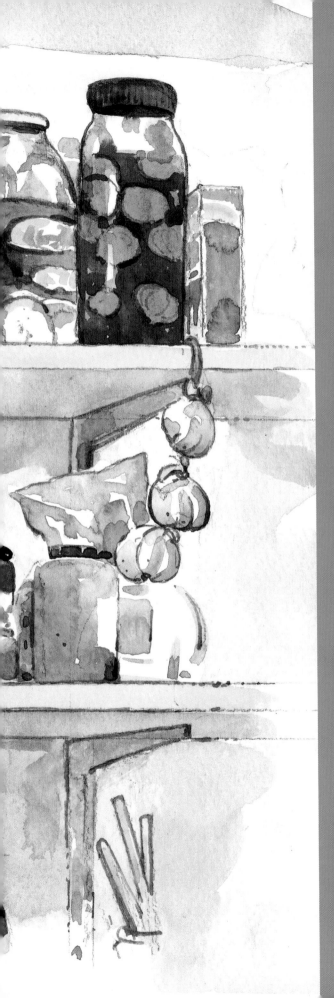

PAINTING IN THE HOUSE

Familiarity with your surroundings can make you oblivious to painting opportunities, but in fact there are many subjects right under your nose. Examine your home from an artist's point of view and you will see everything afresh.

Stairways, passages and doorways can suggest new ways of interpretation. Look closely and you will observe there are compositions on shelves and in drawers and cupboards, just waiting for you to discover them. Even details such as knobs and locks can make unusual and interesting paintings. Making pictures of your surroundings will teach you to find subjects even in the most commonplace items.

◄ **The Pantry Shelf**
24 × 28 cm (9 × 11 in)

The view inside your food store can produce colourful subjects and a range of shapes to paint.

BROAD VIEWS OF INTERIORS

Painting your surroundings can not only be stimulating and fun, it can also provide a wonderful visual diary of your surroundings that you may treasure if you move elsewhere. I recently came across a drawing I made years ago of the interior of a farmhouse. The family who lived there are long gone, but this drawing stands as a fascinating record of how it looked that day in August 1965 when I drew it. I have made drawings and paintings wherever I happened to be, including when I was in hospital. Even if you are stuck in bed, there are will be things around you that you can use as a subject.

Try a view of your living room. You can arrange the furniture just as if you were painting a still life, only on a larger scale. Check the lighting: does the room look better by day or by night? Do the lamps make pools of light that could be part of the composition? Does sunlight throw pleasing shadows across the room? Your kitchen area also probably offers possibilities, and the underlighting on kitchen units often highlights objects in an interesting way.

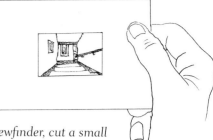

▲ *To make a viewfinder, cut a small rectangle out of a larger piece of card. It will help you select a composition.*

Using a viewfinder

To find likely compositions, make a viewfinder from a rectangle cut out of a piece of card. Hold it in front of you and close one eye in order to see better. Decide whether the composition will look best as a landscape format, which will render a broader view, or as an upright portrait format.

▼ **My Sitting Room**
16 x 24 cm (6¼ x 9½ in)

This broad view of my sitting room was drawn and painted exactly as I saw it.

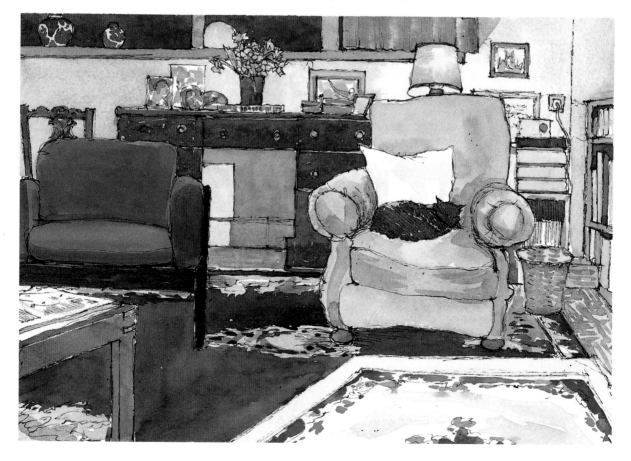

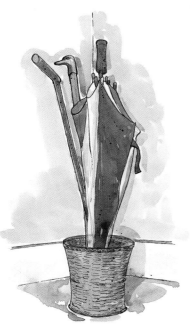

▲ *You can make studies of small subjects such as this umbrella and stick stand.*

▶ *Low lighting, deliberately distorted perspective and leaning angles transform this stairs and passageway into something quite different from the reality.*

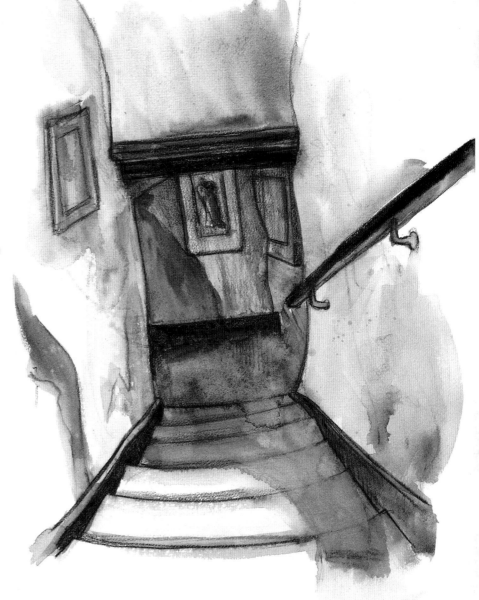

Hallways and stairs

Take a tour around your home environment, trying to see it as though it were strange and new. Looking at it this way will aid you in viewing it with an artist's rather than a homeowner's eyes. Holding a mirror up to the scene you want to paint will reverse the composition and present it in an unfamiliar light. Now put down the mirror and look again. This should help you to decide whether there is a composition there that you wish to paint.

Look at the shapes of the walls, passages and stairs in your home. The sweep of a flight of stairs might be your starting point, particularly if the banisters are attractive, or the angle of the wall and ceiling. Ask yourself what the composition would look like if you placed objects on the stairs – plants, flowers or baskets, for example – to change the painting into a still-life interior. Use your viewfinder as you would a camera, and select how much you want to paint.

Imposing a change

If you can't find what you want, don't despair. Try another way to see things creatively by altering the lighting. You can transform a passage and stairs by, for example, illuminating them with a lamp placed on the floor. If you have a spotlight desk lamp, use it to throw light from other angles in order to achieve a composition you like.

Don't feel you have to stick with straight lines just because the house has them. Try tilting the angles of the walls, stairs and ceiling so they lean crazily, even to quite bizarre effect.

CLOSE-UP VIEWS

If you don't want to tackle anything as large or ambitious as the main areas of your house, here is another idea you can try. Look around your environment again, this time searching for smaller objects. Decorative details such as doorknobs, handles and carving on furniture all make interesting subjects, for example, and you can gain a good deal of satisfaction from making a carefully observed study.

Painting details such as these means you are not constrained by having to do a 'finished' picture. Try painting them as vignettes, with the background colour fading away behind them.

Line and wash is an ideal medium for rendering hard, metallic objects, while you could use watercolour and coloured pencils for carved details; the choice is yours. Consider treating small details

▲ *Details such as this handle from a chest make interesting small vignettes in line and wash and work particularly well framed together as a group.*

such as these as a project about your home. You could complete a series and then group them together as a series of small vignettes mounted inside a picture frame.

Finding new views

Cupboards and shelves are good subjects. The viewpoint that you use will make the subjects appear fresh again, so try looking down or up to your subject, or even along a row of objects in order to create unfamiliar viewpoints. Deliberately looking for the unusual will make your painting fresher and stimulate your creativity, as will being adventurous rather than representational with your use of colour.

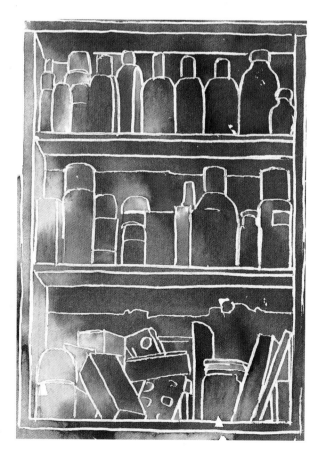

◄ *Here I have treated the contents of my bathroom cupboard as white shapes, using masking fluid and a pen, washed over with wet-into-wet colour. I chose to interpret colour freely to make familiar objects less immediately recognizable.*

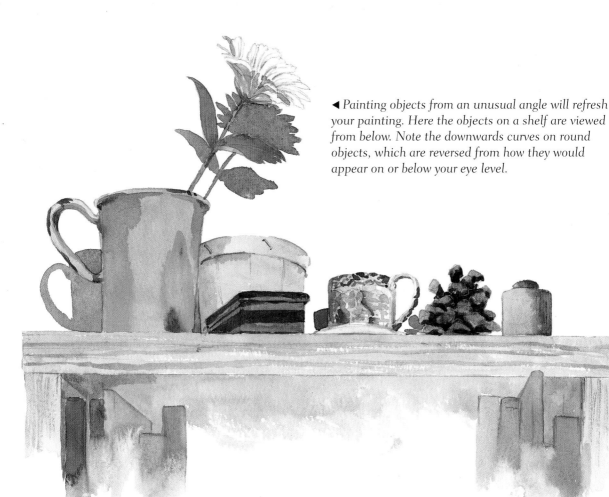

◄ *Painting objects from an unusual angle will refresh your painting. Here the objects on a shelf are viewed from below. Note the downwards curves on round objects, which are reversed from how they would appear on or below your eye level.*

PROJECT

THE CONTENTS OF A DRAWER

- Try painting the contents of a kitchen drawer from above. You can arrange the contents however you like, or just paint them as you find them.
- Paint them as they are in real life, then use adventurous colour combinations.
- Try the subject as a coloured drawing. Use a pen and wash of inks or watercolour, choosing colours appropriate to the utensils' purpose: a vegetable knife could be green, a carrot-cutter orange, a carving knife red and so forth.

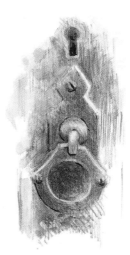

◄ *Small details make interesting studies. This brass lock to a cupboard was painted using watercolour and coloured pencils.*

DOORWAYS

Doorways make natural frames around a composition. They also carry a strong significance as exits and entrances, and you could use this to give meaning to a series of paintings of doorways in your home. Is each a doorway into a world within – your world – or does it open onto the wider world outside? Think about these things as you paint and draw; art is not just about learning clever techniques for creating three apparent dimensions upon two. You are making a statement unique to yourself.

Once you have planned what your statement in paint is about, then you need to plan how to achieve it. It may be that the scene you see before you is perfect as it is. However, as with stairs and passages, you can create atmosphere and interest by selecting how you light it. Strong lighting thrown in certain directions will create powerful compositions. Use your lighting and furniture the way a stage designer does in order to lend emphasis and atmosphere to your paintings.

Decide whether your door perhaps needs to be wide open to reveal what is within, becoming a dark foreground device directing the eye into the room. Alternatively, it may be an integral part of the picture, directing the eye and becoming the means of passage to whatever lies beyond.

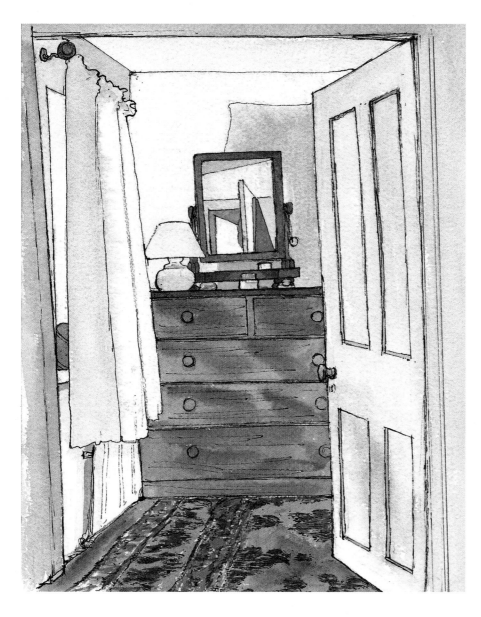

◄ **Bedroom Door**
29 × 23 cm (11½ × 9 in)

Decide what you want to say in paint, and arrange lighting and furniture accordingly. Here I wanted to explore the linear quality of the furniture, window and door, together with the looser-textured pattern of the carpet.

MAKING THE MOST OF MIRRORS

A large mirror is an extremely useful asset to the indoor painter – the larger the mirror the better, since it will obviously reflect larger areas. Full-length dressing mirrors are good if you want to paint figures because you can then use yourself as a model, provided you are able to maintain a pose at the same time as you draw it. However, getting other people to pose with the mirror also is quite a useful device because the sides of the mirror will frame the subject, making it easier to gauge shapes and angles. Look for round mirrors too, for they make splendid shapes to work from if you want to execute a circular painting.

Still life painted in a mirror is fascinating. You can choose whether to show the mirror and the things outside it that it reflects, or you can use the sides of the mirror as the boundaries of your painting and paint what you see inside the shape.

Practical uses

Using a mirror to reverse images is particularly helpful if you have a problem with a painting. Hold it to a mirror and the reversed image will enable you to spot the fault immediately. A mirror is also good as a surface on which to draw around shapes. As an illustrator, I find this a useful aid when checking the drawing of a hand. Holding my hand in the required position up to the mirror, closing one eye and drawing round the image with a felt marker pen gives me an image on the mirror surface that is an accurate shape to copy or trace, and the drawing is easily wiped off the mirror when I have finished with it.

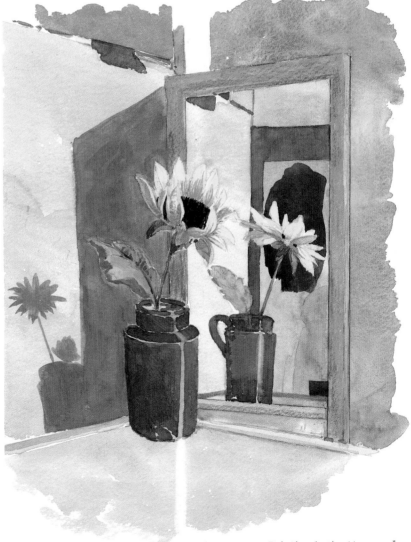

▶ **Seen in a Mirror**
29 × 21 cm (11½ × 8 in)

Here the flower has been painted both in form and in reflection. This creates a fascinating number of angles outside and inside the mirror.

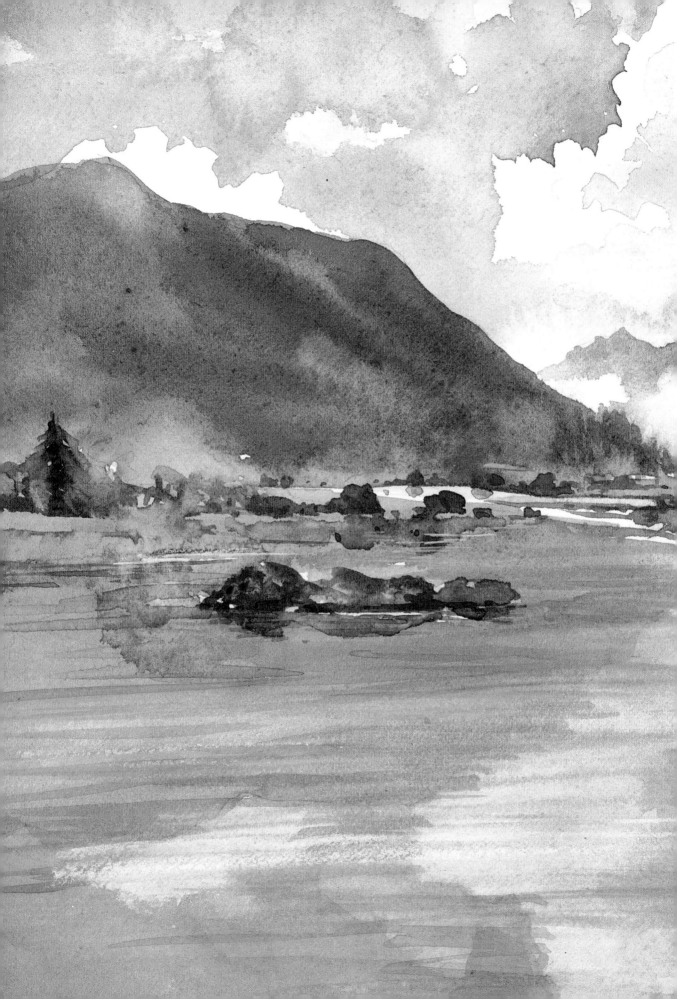

*I*NDOOR *L*ANDSCAPES

Working indoors does not preclude you from painting landscapes on both a small and large scale. You can create your own landscapes at home by assembling some of the elements of a landscape in miniature – for example, rocks placed on the right eye level will stand in for mountains, while logs and twigs will act as reference for trees. Observing the way water rushes or trickles from a tap into the basin below will give you clues as to how a waterfall behaves out in the landscape. The principles are just the same, and the reference is right under your nose.

There is a good precedent for doing this; the great English landscape painter Thomas Gainsborough (1727–88) used models of landscape to create his paintings, and it is said that clay, stones and even broccoli were pressed into service.

◀ Mountains and a Lake
26 × 28 cm (10¼ × 11 in)

An apparently large-scale mountain scene such as this can be created at home by observation of small rocks and water.

CREATING A WOODLAND LANDSCAPE

The pleasure of painting woodland flowers or any other outdoor setting need not be just a dream for the indoor artist; you can re-create the scene at home. While you cannot experience the sights, smells and sounds of a wood, you can make believe with a few props. A piece of log and some flowers in a pot, for example, make a good substitute for the real thing. You can add more details such as leaves and twigs from the garden to stand in for the woodland floor.

Making tonal drawings

The first step is to do tonal drawings of the separate elements of the composition, making sure that the direction of the light is consistent. This will help you to explore the way the flowers grow in relation to each other, the texture of the log's bark and the raggedness of decaying leaves.

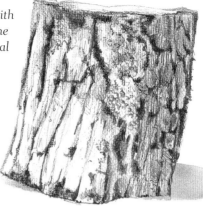

▶ *This log from my fireplace was drawn with the same lighting as the flowers to give a natural effect in the final composition.*

▼ *A study of dead leaves from my garden, executed in coloured pencil.*

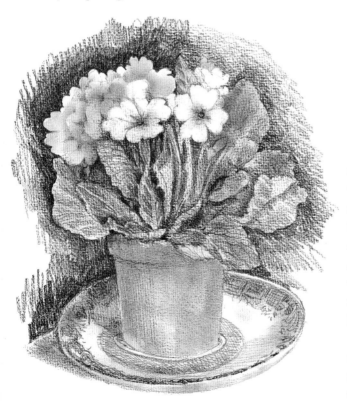

▼ *Making this tonal drawing in pencil of a pot of primroses gave me information about the way the plant grows.*

Putting it all together

Stretched cartridge paper is a good choice of surface for painting flowers such as primroses because its smooth texture allows you to create crisp effects. Draw out your composition first, using your tonal drawings as reference, but omitting the flower pot and lengthening the log into a tree trunk. Remember throughout to pay particular attention to the way the light is falling, since this is crucial to creating a lifelike painting.

Draw in some dead leaves around the flowers and tree trunk, and perhaps add some ghostly tree shapes to the background to give the impression of a wood stretching behind.

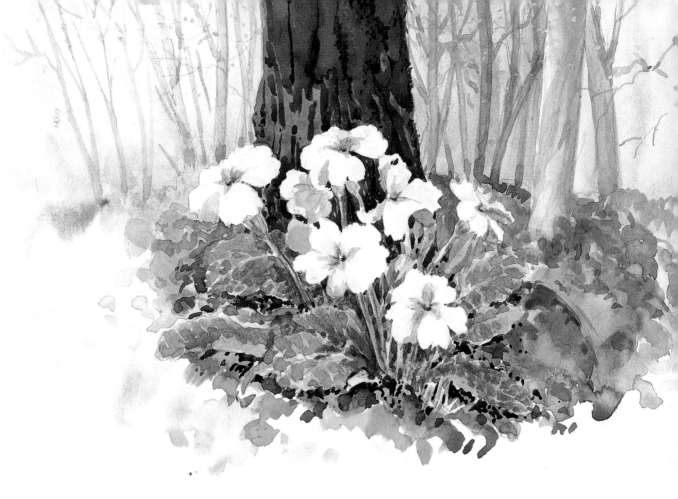

Finally, paint your woodland scene, using your props as your colour reference. The shop-bought flowers may look a little too perfect to be convincingly wild, so you may need to add a damaged petal or ragged leaf here and there in order to achieve a more natural effect.

▲ A Woodland Scene with Primroses
16 × 22 cm (6½ × 8¾ in)

I placed the primroses against the base of a tree and added a background of woodland. As I worked from light to dark tones, the primroses were painted first. A little white gouache was added to the watercolours to create the young tree leaves in the distance.

PROJECT

PAINT AN AUTUMN SCENE

- Buy some mushrooms and 'plant' them in an autumn meadow. Use a mix of open and closed mushrooms – you may even be able to find wild ones on sale.
- Prop them together in a group by pushing cocktail sticks through the stems and inserting them into florist's oasis. Try to make the group look as random and natural as possible.
- Make a drawing of the group, then use it to plan a painting. The group could be set in a ploughed field (try some potting compost around them) or a meadow, if you can re-create grass. Use a misty background of trees or hedgerow to give the feel of an autumn morning.

MOUNTAIN LANDSCAPES

You don't have to look far to create a mountain range. Even if you live in a town, a stone from the garden will make a mountain – and if you have a rockery you will be spoilt for choice of suitable material. An ideal size would be as big as your fist, but it really doesn't matter as long as you can find one that is reasonably irregular. In the last resort, if you cannot obtain a rock, crumple a piece of paper so that it resembles one.

Place your rock on a suitable surface at eye level. Draw the rock and place a straight line across the bottom. Paint in a sky behind, and then paint the rock.

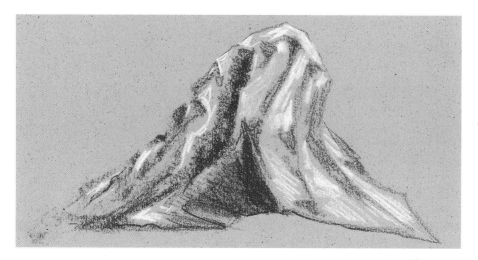

◄ *A drawing of crumpled paper, with a lamp placed above and to one side to simulate the sun. The creases resemble gullies and crevasses found on rocky mountainsides.*

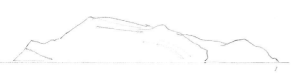

▲ *Place your rock at eye level to draw it. Next, draw a line along the bottom to represent the water line.*

▲ *Paint the sky, then put in light and dark areas on the rock to give contour to the mountain.*

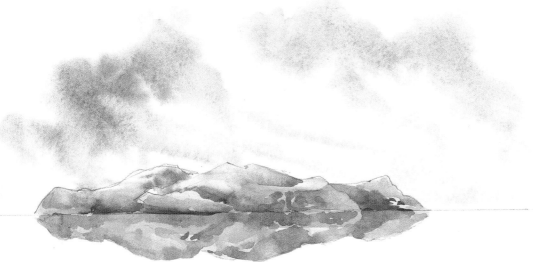

▲ *Here I have painted sky and a rock, then turned the painting upside down and repeated the process to create a reflection in the water.*

Turn the painting upside down, and paint the rock and sky again. Turn back the right way up, and you will have a mountain reflected in a lake. To vary the landscape, paint the rock a number of times, adding to the original drawing to create a mountain range. A mirror placed behind the subject will double the view, and you can even add another at an angle to the first to create multiple images.

Getting the details right

As with the created woodland landscape on pages 54–5, you need to make sure that your eye level is right for your subject and the direction of the light is consistent. When you are sketching low-growing plants to place at the foreground of a mountain scene, put them on the floor so that you are looking down on them – unless you want a mouse-eye view, in which case place them nearer your eye level.

Check that you have created the right lighting conditions to suit the subject. Mountains often have cloud shadows moving across them, so place a potted plant or two with rounded forms in front of the lamp so it shines through and past them. This will create broken light and shadow over the subject you are painting. If you want a jungle flanking the mountains, use the potted plants too, plus a little imagination. The naïve artist Henri Rousseau (1844–1910), who never had the chance to visit the tropics, found models for his jungles among the exotic species in the Jardin des Plantes in Paris.

▼ Mountain Reflections
23 × 33 cm (9 × 13 in)

This painting was achieved by simply repeating the shape of rocks and crumpled paper in order to create a whole landscape.

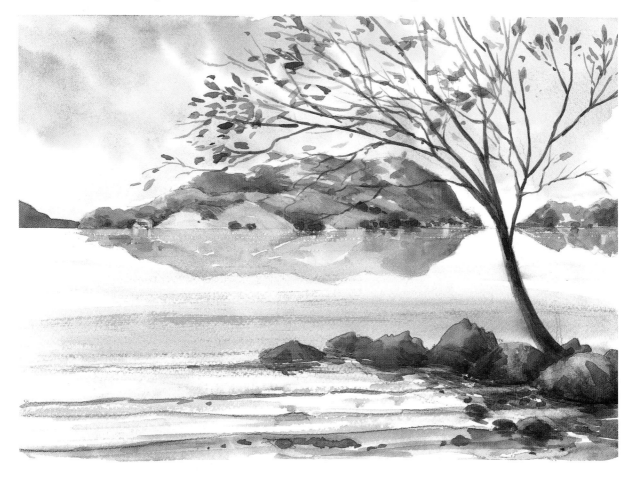

WATER IN THE LANDSCAPE

Water is a fascinating and expressive subject to paint. It communicates mood and atmosphere according to the nature of its surface, from crashing waves to still, tranquil pools. Spend time studying water when you can, since it will help you to understand its movement and reflective qualities and therefore to paint it better.

If you cannot get out and about to observe it, use the water in your bathroom to learn from. Pouring water into the bath, putting obstacles in its way and using taps to stand in for waterfalls can all help you to understand better what you see in nature. You can also make a miniature rock pool by gathering a bag of different-sized pebbles. Place them in a plastic lid or the lid of a can of household paint. Pour over clear furniture varnish to make a 'pool'. Allow to set, and you have a perfect rock pool to paint whenever you need it.

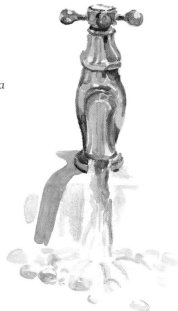

▶ *Falling water from a tap is no different from a sheer waterfall. Use the water in your house to help you understand what it does in nature.*

Falling water

Many waterfalls are, in effect, staircases, with 'treads' and 'risers' breaking the flow. Seeing them like this will help you to handle the way the light falls upon the water. As with a staircase, check to see if the 'tread' or the 'riser' is in light or shade, which will depend upon where the sun is. For example, quite often the water falling down is not as bright as it appears on the top of the fall – unless the river is in spate, in which case the angle of the water being pushed over the fall will be flatter, causing it to catch the light more. Careful observations of how water acts in nature will bring a verisimilitude to your painting and communicate the nature of the scene to the viewer.

▲ *Treat a waterfall as a staircase and check to see if it is the 'treads' or the 'risers' that are in shade.*

▼ *Whether waterfalls drop a few centimetres or many metres, the same principles of light and shade apply.*

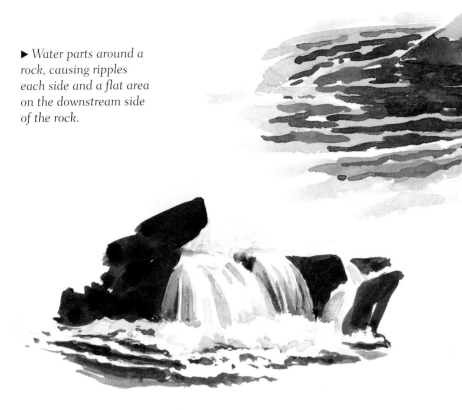

▶ *Water parts around a rock, causing ripples each side and a flat area on the downstream side of the rock.*

◀ *Foam is water full of trapped air, which makes it appear white.*

Interrupted water

As the water tumbles its way down the rocks in its path the air is caught within it, causing white foam to form. It lands at the bottom of the fall, hitting the water below with such force that it pushes itself down and surfaces as foamy bubbles. These bubbles then flatten out into ripples and continue their way downstream. The higher the waterfall and the fiercer its spate, the more dramatic the effect will be.

In calmer stretches of river, if the water cannot pass over a rock it will part around it and rejoin its path below it. This results in ripples around the rock and flatter, calmer water below it. You can study this effect by putting a few objects in your bath.

PROJECT

PAINT A WATERFALL

- Find a photograph of a waterfall in your reference files and make a painting from it. It could be something truly spectacular or perhaps just a small and friendly mountain stream dropping steeply between grassy banks for no more than a couple of metres.

- Remember that the waterfall is a series of steps, no matter how big or small, and work methodically on the direction of the light so that you are consistent throughout in how you place your highlights and shadow areas.

- Look to see how calm the water is just before it reaches the top of the fall. Take the opportunity to make the most of the contrast between that flat sheet of water and the turbulent white foam that accompanies the waterfall's journey downwards and spreads outwards into the pool at its base.

PAINTING REFLECTIONS

Still reflections

On still water, reflections appear like mirror images, including that of the sky. The first step in painting water is to lay in the sky colour, remembering that it must indeed reflect the weather conditions – dramatic clouds above blue water will not look convincing.

To increase the feeling of light on the water, scrape a straight line in the distance with a sharp craft knife. Once you have done this do not paint over the area, since the paper surface has been broken and will not take any more colour.

For distant reflections such as faraway mountains, drop in the colour while the water area is still damp to produce a soft, diffused effect. For landscape features nearer to the foreground, add the colour when the water is dry to give more hard-edged, distinct reflections. Dark objects will appear lighter in reflection, while light objects reflect a little darker in tone, the colour being lightly greyed. Objects will be reflected back at an opposite angle to how they are on shore.

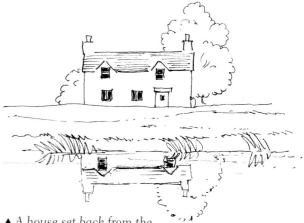

▲ *A house set back from the water's edge will be only partly reflected.*

If you need to paint a reflection of an object set back from the water's edge, measure the height of the object and compare that with the distance from its base to the water. Only the part of the object that is above the latter measurement will be reflected.

Broken reflections

Disturbed water will fragment reflections. To show this, lay in the sky tone, then add short broken or curved lines to suggest the reflection. Remember that reflections are affected by perspective, so they will appear wider as they near the foreground.

Where disturbed water is reflecting sunlight, using dry brush technique on Rough paper will allow the paper to show through, giving broken highlights.

▶ *Calm water produces almost mirror-like reflections. A slight ripple at the back has been scraped out using a knife.*

▶ *Broken reflections give an appearance of a wind-ruffled surface.*

SEASCAPES

Being an indoor artist does not mean that you cannot paint exciting subjects such as the sea. You will have to work from photographs, but as long as you study them carefully you will be able to tackle marine subjects successfully.

Waves on the sea obey the laws of perspective in that they become smaller and flatter as they recede. Start with a straight line on the horizon, even if you are planning to paint huge, crashing waves coming in to shore; establishing the horizon line first will help you to place your wave patterns and angles correctly from the distance to the foreground.

Think of your waves as small moving mountains. They are pushed up and down on the surface of the sea, receiving light and casting shadow. Seen as a diagram, wave patterns appear rather like brick patterning, one wave in the front appearing between two behind it. As the wind and tide carry the sea onto the shore, breakers occur. These are pushed upwards by the force of the sea from behind and eventually surge onto the beach.

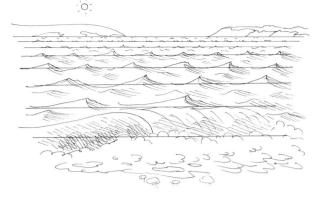

▲ *Waves become flatter as they recede and make a pattern resembling brickwork. Breakers are like tubes, being pushed upwards by the water behind. As they reach the shore they crash into lace-like foam.*

▼ **Breaking Wave**
25 × 35.5 cm (9¾ × 14 in)

Where the wave rises the base is dark in shadow, while near the top the wave thins out and catches the light. The water flows in along the shore in a series of curves.

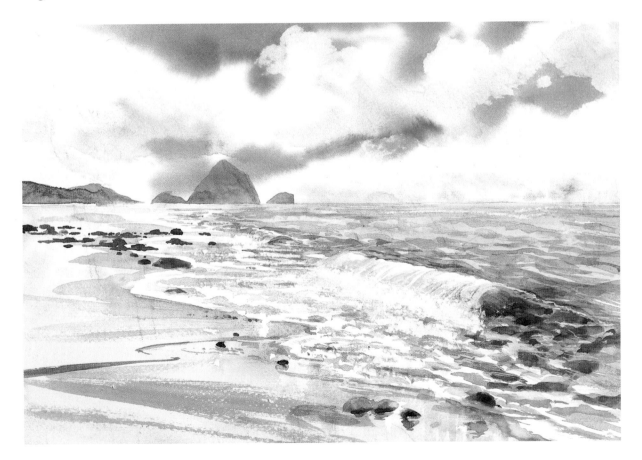

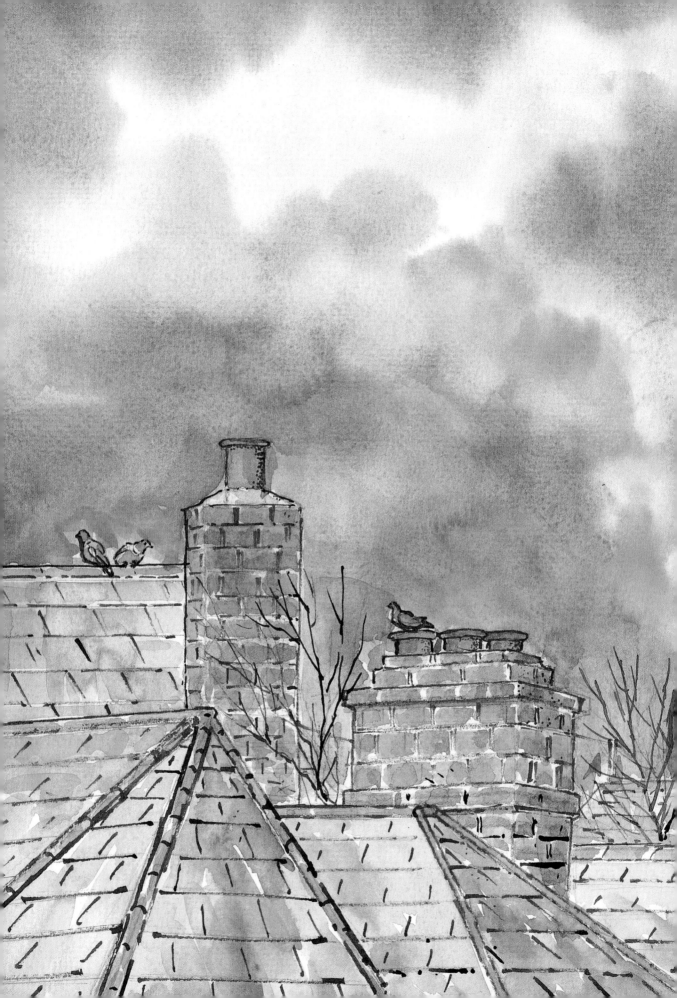

PAINTING FROM YOUR WINDOW

The view from your window can become the source for many paintings on many themes. You may want to paint the effect of changing light throughout the day, or the same scene in different weather conditions and seasons.

Try using a variety of media to suit your surroundings. Line and wash is good for interpreting huddled town houses, making strong linear shapes, while if you live high up in a block of apartments, watercolour skies will provide splendid subjects. I live in a small country village, so old stone buildings and the village green are all around – but wherever you live there will always be something to see.

◄ View of the Roofs
26 × 39 cm (10¼ × 15½ in)

You are never without a subject where there is a window. A room on an upper floor gave me a picture of roofs, trees, birds and sky.

DRAWING ONTO A WINDOW

A good way of recording the scene from your window is to use the glass to help you establish the initial drawing. It is a very successful way of drawing out a composition without having to know too much about perspective, since you just trace over the lines you can see. It should not be regarded as cheating, for the German artist Albrecht Dürer (1471–1528), who no doubt did know a lot about perspective, is known to have employed a similar device and indeed did a drawing of it.

You will need sticky tape, a ruler or set square for 'boxing' the drawing, a fine felt tip marker or technical pen and a sheet of clear acetate of the kind sold for overhead projectors. You can use clingfilm if you cannot obtain this, though its tendency to wrinkle can be a problem. If you are really stuck for clear film, you can draw with pen direct onto the window and wipe it off afterwards.

▲ *Draw your view onto a piece of clear film stuck to the window, using a felt tip or technical pen. Be sure to close one eye or you will create conflicting viewpoints.*

Making the drawing

Tape the acetate sheet on the glass where you want to draw your view. Close one eye (otherwise you will have two viewpoints) and draw around the shapes you see. You will only be able to draw the main lines of the composition – detail is not really possible, but the drawing will provide the framework for your painting. You will soon realize that in order to make a successful drawing you have to keep your head absolutely still, since any slight change of position will alter your viewpoint. Remove the sheet from the window, taking care not to rub off the ink as you do so, and allow the ink to dry.

Draw four lines around the drawing to frame it, then rule a grid of equal-sized squares on the composition. This process is known as 'squaring up'.

◀ *Remove the drawing from the window and box it into equal squares. Redraw the boxed squares onto watercolour paper, making them larger if required. Copy the image box by box onto the paper you are using.*

Next, draw the same number of equal-sized squares on the sheet of paper you are going to paint on. The squares can be made larger than those on the film so long as you use the same number.

Lay the film drawing on another piece of white paper so you can see it more clearly, then copy the shapes you see in each grid box onto your paper. You are now ready to begin painting.

Taking it further

This grid device can be used for all sorts of subjects, and you can buy or make a set of grid lines to incorporate into your viewfinder. This way, when you are working out a composition, the viewfinder will also give the contents of each grid box. The major problem would be the necessity of having to keep your body as well as your head completely still, since you would be holding the viewfinder rather than drawing on the window where the rigidity of glass would steady your vision.

In addition to drawing what you see from your window, remember you can add or subtract elements. If you don't like a tree or building exactly where it is, move it. Likewise, if you feel the scene needs signs of life, add in a dog, a pedestrian or a flock of birds. You are the creator of your world on paper, so you can choose what you want and where you want it.

▼ View from the Window
15 × 23 cm (6 × 9 in)

This is a completed wash and line painting of the view from a window, using tracing and squaring up. I enlarged the painting by half as much again. I worked in brown ink to emphasize the linear quality I felt the composition required and added a tree and some ducks to balance the composition.

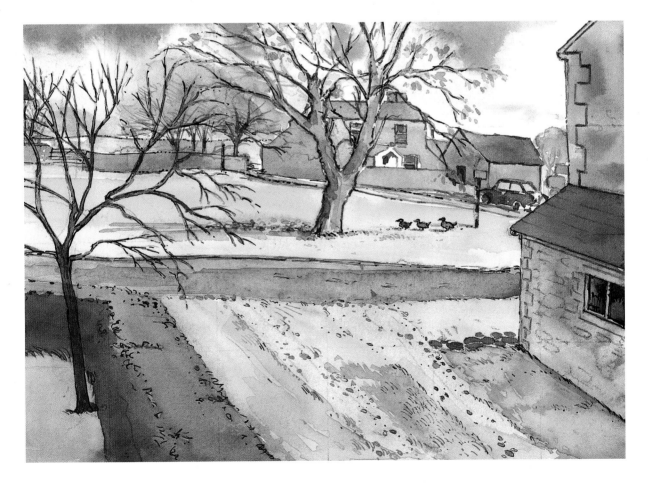

PAINTING SKIES

If no other view from your window appeals, paint the sky. Be sure to keep the horizon low so that the sky is the subject rather than the backdrop – though recording skies will be immensely useful for many other paintings as well. John Constable (1776–1837), the great English landscape painter, devoted a great deal of attention to studies of skies. These became vital parts of the masterpieces he subsequently painted, although the paintings he did of skies alone are magnificent.

Study the sky through changes of weather and time of day. Keep a painting diary where you record and experiment. Painting a variety of skies will help lodge them in your visual memory for use later on.

Skies are fleeting things and demand a fast approach. Keep a sketchbook of watercolour paper and paints near the window so that you can be ready when the moment comes. Paint quickly, throwing caution to the winds in order to get down what you see in front of you. Often this will give a truer record of what the eye sees than a painting that is more thought through.

Your choice of colours will be your own, but these are a few points in relation to skies that you may find useful.

Sunny skies
When the sun is out the light is warm, so make your clouds ivory rather than leaving white paper when working with watercolour. If the light is warm, the shadows are cool. Try putting Cobalt Blue or French Ultramarine with Burnt Sienna into your cloud shadows.

Grey days
On days when the sun is not shining the light appears flat and cool (bluish). Any shadows that do appear from a gleam of pale sun are warm.

Stormy skies
It can be difficult to create the intense deep blue of thunderclouds in watercolour. Mix French Ultramarine with Cobalt Blue and a small amount of white; when it is laid on the paper, smudge in a little blue pastel with your finger to create the colour you need. Painting a sunlit landscape with storm clouds looming behind makes a dramatic subject.

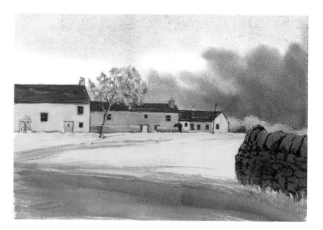

▲ *To show an approaching storm I dropped in darker colour wet-into-wet. When it was dry I added a little French Ultramarine and grey pastel into the darker parts to intensify the colour.*

◄ *In this study of a summer sky with clouds I kept the rest of the painting as simple as possible to make the sky the subject.*

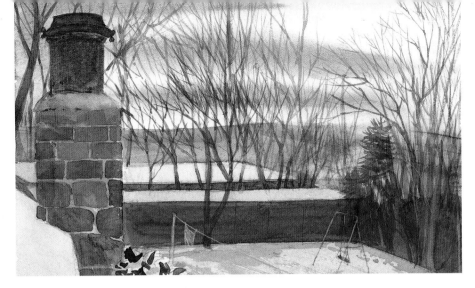

▶ Twilight Snow from
My Window
16 × 23 cm (6¼ × 9 in)

*As the light drains from
the land with the setting
sun, blues and deep greys
predominate.*

Skies and snow

When snow is imminent the sky will appear a
yellowish grey. Fallen snow will reflect the colour of
the sky. If the sun is out it will be warm in the lit areas
(try adding a hint of Lemon Yellow to your wash), and
the shadows will be cool. Mauve-blue shadow works
well and enhances the warmth of the snow because
yellow and purple are complementary colours.

Rainy skies

Heavy rain will create a blurred effect. You can give an
impression of driving rain by slanting your painting
strokes slightly to right or left. Skies are neutral grey
and the light appears flat.

Times of day

Use Lemon Yellow for morning light and deeper
colours such as Cadmium Yellow Deep to create
evening light.

▲ *Falling rain often causes a slanted, blurred effect.*

PROJECT

PAINT A RAINY SKY FROM YOUR WINDOW

- Create a painting of steady rain
 from your window. The light will
 be dull, so avoid strong contrasts
 of light and shadow.
- When painting, slant your brush
 marks to create falling or driving
 rain. You can also scrape the
 paint with a sharp knife.
- For a greater challenge, try
 painting on a day when sharp
 bursts of localized rain are
 illuminated by shafts of brilliant
 sunlight. You might be lucky
 enough to see a rainbow, giving
 you the whole colour spectrum.

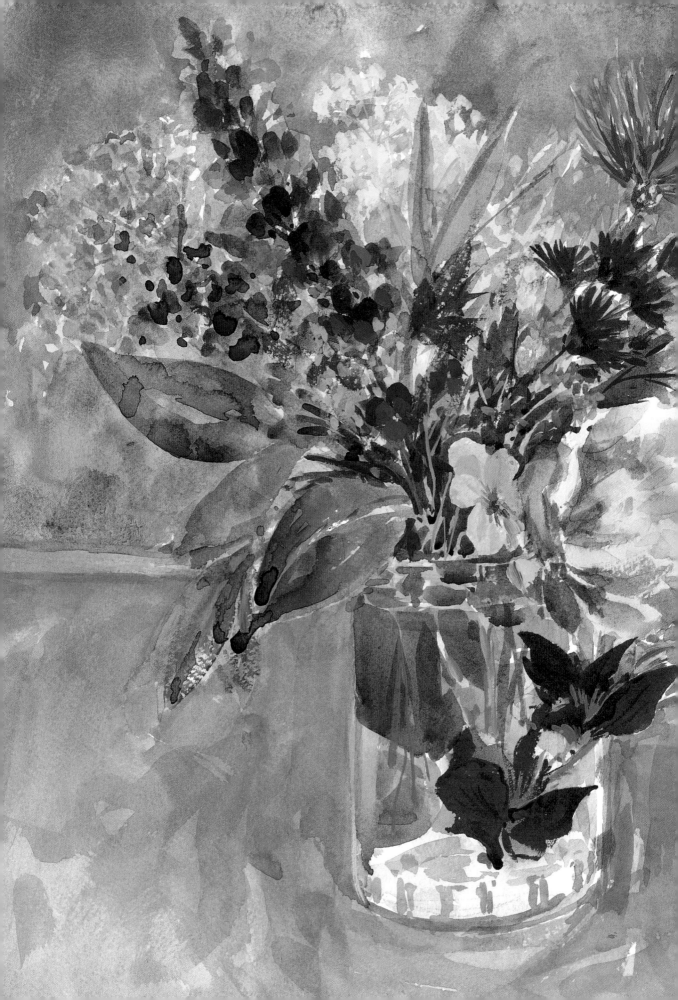

PAINTING FLOWERS

Flowers provide a good source of inspiration for the indoor painter. In the home they are also easier to control in terms of lighting and composition than when they are out in the garden or in the wild. Analysing them singly as simple shapes can take a lot of anxiety out of painting them, and putting them in a range of attractive containers and in different groupings ensures that you will never run out of subject matter.

Flowers also tempt you to try a variety of media to suit their particular characteristics. The luscious rich colouring of anemones may look wonderful as a collage, for example, while the delicacy of a snowdrop will benefit from a gentler approach of pencil with watercolour washes.

◄ **Summer Flowers**
37 × 56 cm (14½ × 22 in)

These flowers were painted loosely to capture life and movement. Adding a smaller container of flowers helped to balance the composition.

FLOWER SHAPES

The structure of flowers can sometimes defeat the artist. If you reduce the flower to a simple shape you will find it easier to deal with; understanding the basic form will help you succeed with even the toughest-looking complexities and how they are affected by light and shadow. There are many shapes you can use, including cylinders, cones, spheres, cups, bowls, saucers, flattened discs, radiating spikes and triangles.

Spheres

According to their variety, roses, peonies and dahlias may be an exactly spherical shape. Seeing them in this way makes it easy to describe their form.

Cylinders

This shape is often found, with tulips, foxgloves, bluebells, penstemons and some campanulas among the many species. Check the end of your cylinder (the mouth of the flower) to see if it has a lip, as in the foxglove, or curls upwards like the bluebell.

Triangles

Pansies are among the flowers that fit a triangular form. Start your drawing with a loose triangle and it will be much easier to construct your flower shape.

▲ Some roses are perfect spherical shapes which enable you to calculate the effect of light and shadow on the form.

▲ In their simplest geometric form, pansies are triangular.

▶ This unopened tulip is a simple short cylinder in shape.

▲ Cylinder shapes may be either upright or hanging like bells as in the foxglove.

Saucers

Some flower forms are shallow saucers, such as Japanese anemones, while others, including some roses, resemble bowl shapes.

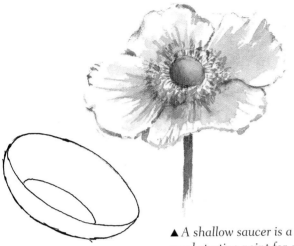

▲ *A shallow saucer is a good starting point for a Japanese anemone.*

Cups and saucers

You may encounter a combination of shapes, for example in a daffodil. Here the cup becomes trumpet-shaped and sits in the middle of its saucer. As the flower turns, the shape of the saucer will elongate into an oval or ellipse. Drawing this first will help you get your petals in perspective.

▼ *With a daffodil, the cup sits in the middle of the saucer. Using a simple shape like this will help you understand how perspective works when painting flower subjects.*

Leaf shapes

Leaves can be treated in the same way as flowers. Check your leaf – is it oval, round, diamond-shaped or like an elongated spear? For example, a holly leaf can be simplified down to a long diamond form. Sycamore leaves are described in botanical terms as palmate, meaning that they are shaped like a hand. Bearing this in mind, start by drawing the veins of the leaf radiating outwards, then widen the shape around each vein to an oval that narrows towards the base of the leaf. Complete by drawing the profile of the leaf around the oval shape.

Even if the plant or tree has a complex pattern of leaf shapes, you can still reduce them to a simpler form. Be careful, however, when you are trying to paint leaves en masse. Delineating them carefully is not the best way to tackle this. Viewed together they make a much simpler, larger shape, and individual leaves are only apparent when seen against a darker or lighter area. You need only show any detail where they are set against a sky or another colour such as that of a flower.

▲ *Simplify leaf shapes to help you portray the form accurately. Here the rose leaf started as an oval and the holly as an elongated diamond, while the sycamore is a series of ovals drawn round radiating veins.*

SINGLE FLOWER STUDIES

Single flowers make good subjects for painting and give courage to the anxious artist shuddering at the thought of tackling a vaseful. If you enjoy observing detail and working with precision, then this is for you.

Getting started

First find a flower specimen that will stay fresh long enough for you to paint it. Small, delicate flowers will begin to wilt after only an hour or so, even in water. Once you have your flower, put it in a container so that it cannot droop – a tall-necked bottle is useful for single studies. Place it close enough to discern the overall form and once it is in position don't alter it. If you want to check detail that would necessitate moving it, keep a similar specimen beside you. Nevertheless, the flowers will probably move without your assistance over the course of several hours. Tulips, for example, start upright in a container and by the time I am well in progress with a painting

appear to be watching me from a variety of angles that are nothing like the poses they started with.

You will need to have a constant directional light for a few hours in order to maintain highlights and shadows in the same places, so use a desk lamp rather than relying on natural light.

Materials

Work on stretched cartridge paper, or Hot Pressed watercolour paper. You need a smooth surface to describe detail correctly.

I use sable brushes because they don't 'dump' the colour too quickly (a fault of manmade brushes), but this is not essential. Round brushes in sizes 3 and 6 or 8, plus a rigger for stems, are suitable for the job in hand. Rose Madder or Quinacridone Rose will give you the sort of pinks and mauves you find in many flowers such as sweet peas, and for the rest your usual palette should suffice.

▲ *The simple, definite forms of marguerites, sunflowers and Japanese anemones make them a good choice for single flower studies.*

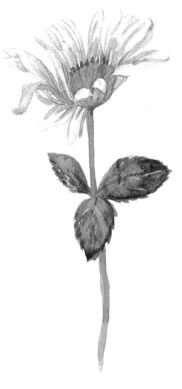

Stepping up the numbers

If the thought of painting flowers en masse worries you, work your way up gently by starting with a couple or a spray. Pick something relatively uncomplicated such as daisies, which are a basic saucer within which you draw petal shapes.

When you are painting white flowers such as daisies, put a darker background behind so that the white will shine out in contrast. The shadows on the petals will be a range of greys, and aiming for a coloured grey rather than a neutral shade will make them more interesting. Try a mauve-grey of Alizarin Crimson, French Ultramarine and a little Cadmium Yellow, which will make the white of the petals look creamy, even though the white is that of the untouched paper.

As you draw the group, aim to create pleasing negative shapes between the flowers and particularly the leaves and stems. These negative shapes are as important as the shapes of the flowers and leaves themselves.

▲ *Just one flower can be repeated many times to make a bunch.*

▼ Spray of Flowers
18 × 12 cm (7 × 4¾ in)

Painting several flowers in a spray can be a pleasing alternative to a full vase.

PROJECT

REPEATING A SINGLE FLOWER

- Paint a small group of flowers bunched into a spray or held in a container. If you haven't got easy access to fresh flowers, silk flowers can be a realistic alternative.
- Buy several different varieties to explore. You only need one of each because you can paint the same flower in a number of different positions to give the impression of a bunch.
- Practise first by making a number of studies, concentrating on the way each flower looks at different angles, then bring them together into the final composition.

GROUPS OF FLOWERS

Flowers in containers are a chance for you to rearrange nature by painting them in a controlled setting where you don't have to worry about unfavourable weather, badly placed flowers and poor light. Plan what you want to do in advance, but don't select and place your flowers as if you were doing a flower arrangement – the effect will look very artificial in your painting. Check instead that your arrangement is well composed for your purposes as an artist. Look for a triangular shape in your grouping, a good classical device for making a successful painting. Use the placing of shapes and colours to lead the eye around the composition.

When you are painting flowers in a container, avoid splitting the picture between the two very different elements by creating a visual link from top to bottom. A drooping flower head or a fallen petal is a simple device that will do the job. You might also like to try placing the plant in a corner and grouping two containers together, with perhaps one larger than the other to break up the line.

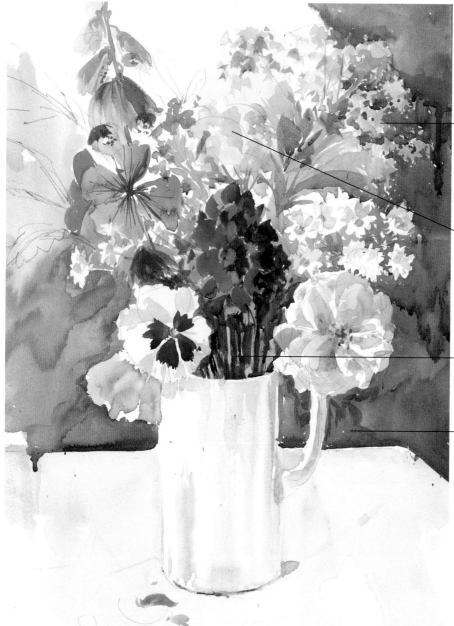

◄ *This half-completed painting shows the stages used in building up colour and form.*

The pale green fronds of *Alchemilla mollis* are only revealed when the darker background is added behind.

A wash of pale green is the basis for all the foliage.

When the pale green wash is dry, mid and dark green tones are added where required, leaving the palest green as light stems and leaves.

The background is added last, containing the colours of the flowers.

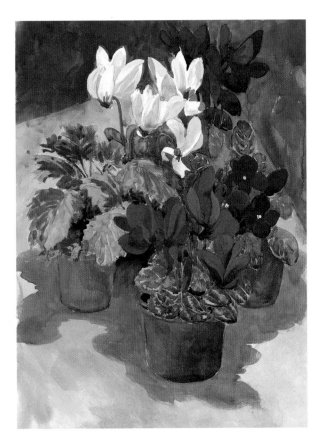

Starting a flower painting

The sight of a jumble of lights and darks, spidery stems and fiddly petals can strike terror into a painter's heart, and the temptation is to start with one flower, draw it out and paint it carefully, then pass on to the next one as a way of tackling the group little by little. However, it is a temptation to be resisted.

Start by looking at the overall mass of the flowers in the container. Can they be reduced to a simple shape? Often their mass can be seen as a fan, with the stems converging to the neck of the vase. Use this shape as a framework in which to place the individual blooms.

Don't be tempted to draw the flowers, otherwise you will end up 'colouring in'. Lay loose washes of colour over the area where they are and gradually cut in with darker colours until you have your flower shape. Paint stems and leaves the same way, laying a wash of the lightest green you can find in them all over the area. When it is dry, work darker tones over the top.

Varying the view

Put flowers in unusual containers: fragile china cups, tin mugs, small bowls or glass jars. Look for unexpected angles to paint your flowers from. How about painting them as a bunch just dropped onto a table?

Potted plants massed together make superb colour studies and can be exciting to paint. Unfortunately there is a tendency to paint potted plants with the flowers and leaves in the top half of the paper while the pot (often a dull red) sits in the bottom, dividing the composition in half. One way to avoid this is to place the group on the floor so that you look down on it, resulting in more flowers and less pot in the centre of the composition.

Find flowers that make you really want to paint them because their colour is so sumptuous, then revel in your brightest-coloured inks and watercolour. For richly textured subjects tissue collage is wonderful, with vibrant colour and subtle batik-like veining where the colour runs beneath the tissue.

◄ Cyclamen
42 × 26 cm (16½ × 10¼ in)

In this composition the pot was placed below eye level to enable the rich colours of the cyclamen to predominate.

▼Anemones
19 × 15 cm (7½ × 6 in)

I painted these anemones in watercolour and stuck tissue over the whole surface. I then added coloured inks.

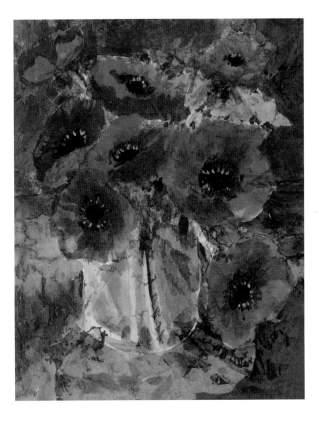

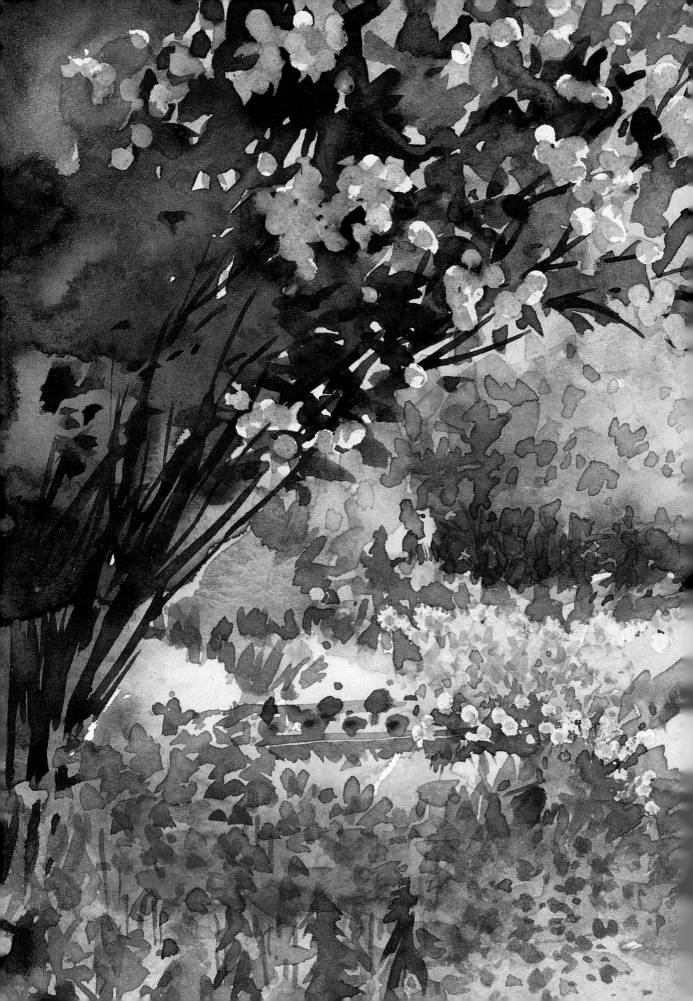

PAINTING YOUR GARDEN

The Impressionist painter Claude Monet (1840–1926) famously drew great inspiration from his garden, so why should not you from yours? Monet's was large, with part of a river diverted to create a pond – a luxury that most of us do not have. However, there is nothing to stop you from planning and growing a garden to suit you as a painter. From general views of your garden to trees and bright borders, you can choose your compositions to paint in all seasons.

Even if you have only a small garden you can plant up pots with flowers and plants that can be arranged as you wish, while your gardening tools can become outdoor still-life subjects.

◀ **Summer Garden**
17 × 26 cm (6¾ × 10¼ in)

Every season brings something to paint in your garden. Here white blossom frames a garden path in late spring.

TREES AND BORDERS

As you look out over the whole of your garden, the idea of painting it may seem overwhelming. However, its major features are probably trees, hedges, bushes and borders, and looking for a way to simplify them will give you confidence.

Trees

Many trees in full leaf are like a round canopy, with the trunk and branches running up the middle. Seen from the ground, the canopy appears to curve more steeply near the top. If, however, you are above the tree, looking down from a window, the perspective reverses, and the curve of foliage bends the other way.

Not all tree forms are full and rounded, but this is the basis for looking at all tree construction. Even in the case of trees with sparser foliage you should be able to discern the overall outline by observing the movement and direction of the leaves.

Borders

Summer borders can be simplified into mounds, with alternating light and cast shade. If you draw out a general shape first then deal with the flowers within it you will have a more successful result than if you try to draw large numbers of flowers singly in an effort to create a mass.

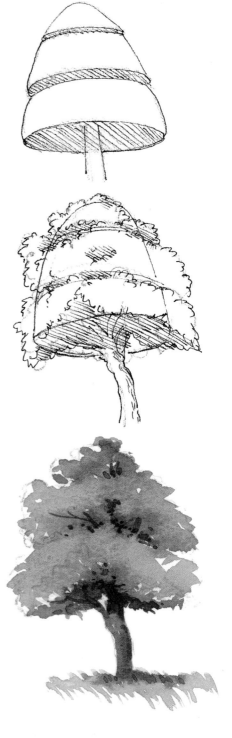

▶ Both borders and overhanging bushes can be rendered as mounds to help you deal with the overall effects of light and shade. Flowers can then be added later into this shape.

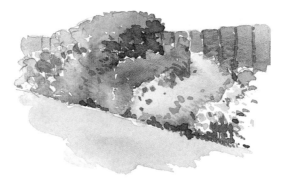

▲ A tree viewed from the ground appears like a canopy. Perspective causes the foliage to arch above the viewer.

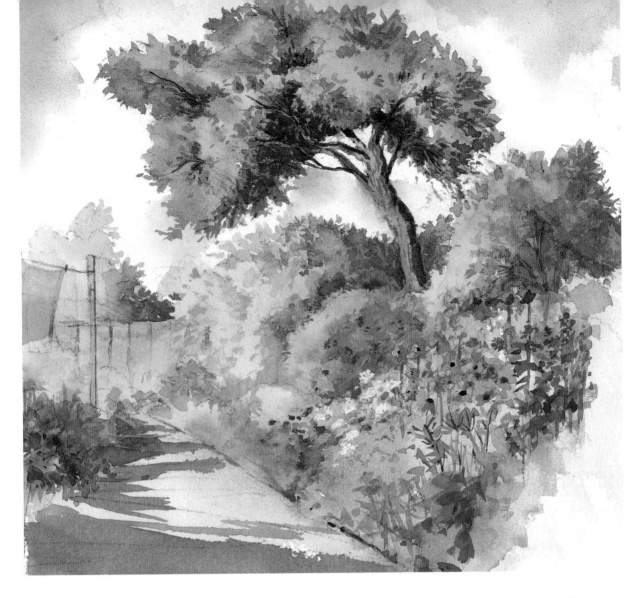

▲ Sunlight on the Border
26 × 29 cm (10¼ × 11½ in)

The elements in this picture have been emphasized to show basic structure. The tree displays a canopy-like form, while the borders have been constructed on simplified mound shapes.

Putting it all together

Once you understand the elements within your garden, it will be easier to put the whole composition together. Always simplify what you see in front of you – it is fatally easy to get sidetracked by detail too soon in the painting, and nowhere is the temptation greater than in a painting of a garden with a lot of attractive plants in it.

Even when you have the basic shapes in place, restrain yourself from trying to include too much information. When we look at plants en masse in a border we do not see everything; our eye takes in salient objects, a strong contrast, a bright colour or a shape. We are aware of the rest of the group but not in a focused way, so there is no need to paint every part of it. The aim is to imply that there are masses of flowers rather than paint them individually. If you do try to paint everything, your picture will appear too busy and obsessional and will be uncomfortable to look at. Giving the viewer a certain amount of information and allowing their imagination to fill in the rest makes for a much more interesting picture.

So how much should you paint? Try the 'blink' test. Stand in front of your chosen view and close your eyes, then open them momentarily and shut them again. What you glimpse in that time is what you paint. This method can be used for any subject with a lot of detail, and is especially good if you are at a loss to know how many bricks to paint in a wall.

STILL LIFE IN THE GARDEN

Use elements of your garden to create a still life in the open air. The most obvious subjects would be a grouping of garden tools, pots or furniture which, unlike the plants, will not wilt before your eyes under hot sun.

To encourage you to think carefully about your palette, try using a complementary theme by placing the colours the objects are in reality on top of their complementaries. If you have any difficulty in working this out, just remember that the three primary colours are red, yellow and blue; if you mix any two together, the resulting colour is the complementary of the third primary. So, for example, blue and yellow produce green, which is the complementary of red.

Using pots and containers

Among the most useful things for an artist to have in the garden are pots or tubs of plants. If your garden is the size of a postage stamp they can be arranged to

▲ **The Garden Tools**
18 × 24.5 cm (7 × 9½ in)

The complementary colours of red and green give 'fizz', with soft honey-brown bulbs, trowel and pot to provide balance. The underpainting was watercolour, while complementaries were added in dry coloured pencil.

▼ **Garden Still Life**
23 × 34 cm (9 × 13½ in)

I placed pots of colourful flowers descending some steps to make a garden still-life group.

◄ The Washing Line
14 × 23 cm (5½ × 9 in)

Washing blowing in the wind makes a simple and energetic garden painting.

suggest a larger expanse than actually exists. Alternatively, they can simply become the subject in their own right.

Group your pots to make a pleasing composition. The same themes apply as when composing an indoor still life: join the objects to each other and use the tallest to help create a triangular shape.

Finding other subjects

Other motifs to paint include washing on a line, which makes a delightful subject. You might want to choose colours for the clothes that echo those of nearby flowers or plants. On a windy day, the painting will be full of energy, while washing hanging still and straight on the line will create a feeling of calm or even baking heat if the painting is full of sunshine.

I have a pond, and the colours of the fish and the water and the effects of light and shade fascinate me. If you have water, it is well worth painting. There is not only colour contrast, but also the contrast between the water and the texture of the plants in or around it. If you have only a small pond with one or two plants, you can easily multiply their number.

Take advantage of your garden pond to observe the effects of light and colour on water. This study will help you to paint water in larger landscapes. I once used part of a tiny pond I had in my garden to create a riverbank scene in a book I was illustrating.

PROJECT

PAINTING YOUR GARDEN SHED

- Draw and paint the interior of your garden shed. It may be large enough for you to sit inside, but if not, you can paint the view through its open door.
- Arrange the pots, tools, bags of compost and so forth to suit your composition. Aim for a range of interesting shapes that will lead the eye into and around the painting.
- Even if you have the most basic and unadorned shed that can be bought from a garden centre, remember that you can improve its appearance on paper. If you have a climbing plant to use as reference elsewhere in the garden, you can transfer it to twine prettily around your shed door.
- A few pots and a pair of gardening boots in the doorway will give the impression of a gardener at work, adding a narrative element to your painting.

BIRDS IN THE GARDEN

Being indoors is a positive advantage when it comes to drawing birds, since they will go about their business undisturbed by your attention. It is relatively easy to attract them to a feeding station near a window where you can watch them. Because they are so swift in motion, spend some time studying their range of movements before you begin to try to draw them.

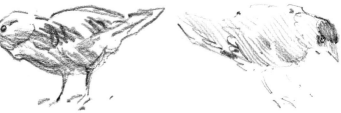

You will need a large drawing pad, A3 size. Because birds are very active as they feed you will start a sketch only to find the bird has changed position. Don't despair – as the bird continues to move, just keep making another sketch on the same sheet. You will end up with a page of bird poses. Having a large sheet of paper means you can go from one sketch to another more quickly than by turning the pages of a sketchbook.

Make sure that you note the direction the light is coming from. The falling of light and the cast shadow will create convincing forms when you paint them.

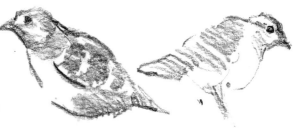

To paint birds you will need photographs as well as observed drawings in order to gain information on colouring. A female blackbird, for example, looks like a rather drab brown bird from a distance, but seen in close proximity the feathers have beautiful subtle markings with a surprising range of colours. I keep a file of bird photographs for reference.

▲ *These sketches of birds were made through my window. I arranged a feeding station so that I could observe them at leisure.*

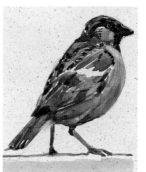

▶ *To enhance the subtle greys and rich browns of the plumage I painted this house sparrow on tinted paper.*

▶ *If you keep a close watch on bird life you may see something unexpected such as an owl.*

▶ *My garden is full of sparrows which live in the ivy on the house wall. They line up to wait for food each morning.*

Avian anatomy

As you look at garden birds, note the differences in body shape, relative length of wings and size and shape of beak. You can even examine the next chicken you cook to gain information on a bird's anatomy – even though the size is bigger, the way the wings and legs are set on the body is the same.

A bird's body can be simplified to an egg shape in order to start constructing a drawing. Next, add the wings and legs. Remember that the legs are jointed at the top, though this is largely hidden by the body plumage. When drawing the head, note that the line between the upper and lower beak can be traced to the bony ridge of cheekbone below the eye socket. This helps you to place the eye correctly in the socket area a little above the middle line of the beak.

▲ *This little blue tit is a regular visitor to the nut container. Use studies such as these to put into a painting later.*

▶ Birds Feeding
19 × 17 cm (7½ × 6¾ in)

This composition was based on birds that visit the feeding station outside my window.

PAINTING PEOPLE

You can still paint people even if you can't go outside for inspiration. There are photographs to work from, passersby outside your window and visitors who can be persuaded to sit for you. For a model who is permanently on hand, of course there is also yourself.

To achieve some success you need to know a little about anatomy since that is the foundation of all human form, but above all you must be interested in people because that will make you observe them closely. Since my background is in book illustration as well as painting, I am fascinated by the way people behave and I enjoy the humour that is often there in the way they interact with each other.

◀ Tourists in Venice
19.5 × 31 cm (7½ × 12¼ in)

This line and wash picture of tourists outside a mask shop in Venice is a composite of two sketches, one of the women outside the shop and the second of a man and the cat.

FACIAL FEATURES

The way the features are arranged on the face are of course very individual. A lantern jaw and a small receding chin will be in very different proportion to the nose and mouth, for example. However, when painting faces there are general rules that can be followed, and if you bear them in mind you will be more alert to it if your subject's face does diverge from them.

• The eyes are half-way down the face.
• The ears are on a level with the eyes.
• The tip of the nose is half-way between the eyes and the chin.
• The mouth is one-third between the nose and chin.

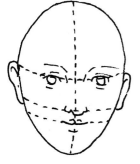

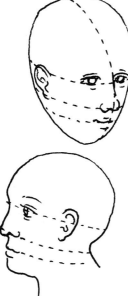

▲ *These sketches of a head show the placing of the eyes, the nose and the mouth.*

Eyes

The eyeball is set into a hollow in the skull. The iris and pupil are almost never seen as completely rounded; the top and bottom lids always cover them

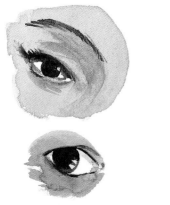

slightly. The upper lid casts a small shadow over the top of the eye, including the iris, and is longer than the lower lid. Joining them at the corner will make the eye look artificial.

The pupil is the darkest part of the face and is black. Highlights on the eye can be found on the pupil. The highlight is often left as white paper in a watercolour, although in overcast conditions it is slightly more blue. Isolating the highlight with a pencil before painting makes it easier to preserve.

Noses

Noses are bony at the top and soft at the tip, making their shape difficult to achieve on a full-face pose. A shadow on the side of the nose will make the form easier to show, so arrange your lighting from the side rather than the front.

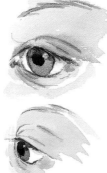

Mouths

The central line between the upper and lower lip is unique to each of us and is the darkest part of the mouth, so draw it first. Outlining the top and bottom lip flattens them and looks crude. Note that the upper lip is more shadowed than the lower one if lit from above. Avoid an open mouth if you are painting a portrait because showing the teeth makes the sitter look artificial.

PAINTING A SELF-PORTRAIT

You don't need to go looking for models when you want to make a portrait – just find a mirror and some lighting and you have your subject. It is a good idea to use a desk spotlight rather than daylight for lighting so that you can reproduce the conditions if you do not finish in one sitting. Make your lighting strong to help you render the light and shadow on the structure of your face, which is crucial to gaining a likeness. It is the shape of the skull and the way light falls on it that makes us look as we do. That is why we can recognize people we know from a great distance when detail is blurred and all we see is light falling across the bone structure of the face.

Try studies in charcoal or pencil before painting to give you a chance to familiarize your shape before you start. If you find it really hard to get the basic shape, try drawing your face on the mirror with a felt tip marker and then make a tracing of that.

▶ *A pencil study of myself in a mirror.*

Creative self-portraits

It is possible to paint yourself full-length if you position a long mirror down a passageway and draw yourself from the other end, observing how light falls across your figure. Try a double portrait of yourself to produce two people wearing different clothes. You can explore this as far as you like by illustrating scenes from novels or films, using yourself as the main character and even dressing up in appropriate costume.

◀ *For this self-portrait in watercolour I used a desk spotlight to ensure constant light direction.*

USING YOUR SKETCHBOOK

Keeping a sketchbook allows you to make mistakes with freedom, for you can simply turn the page and move on to the next drawing with little time wasted and no witness to your errors. In this way it is invaluable, since it is through making mistakes that you will develop your skills as an artist. Use it constantly and it will reward you richly, becoming your visual diary. I still have nearly all my sketchbooks stretching back to college days.

Use your sketchbook to record anything and everything that attracts you. It may be a drawing of a tree from your window, visitors to your home, passersby in the street or characters on television. If I go out to a concert or the theatre I take my sketchbook with me. I have even drawn at weddings.

Quick sketches of people going about their business will provide you with plenty of reference material.

On train journeys and as a front-seat passenger on motorways I practise speed drawing, which is a wonderful teacher for the visual memory. Motorway journeys are particularly good for sky studies. Of course my sketchbook is always with me when I go away on holiday, for there is the chance to record all kinds of unfamiliar scenes to inspire paintings when I return home.

My sketchbook is small, which means I can draw quickly and be reasonably unobtrusive; it can be tucked into my pocket at a second's notice. The best sketchbook for taking out and about is a hardbacked one of A5 size, which will be sturdy and easy to store in a pocket or bag. Buy one that has good-quality thick cartridge paper so that you will be able to do little watercolours in it as well as drawings.

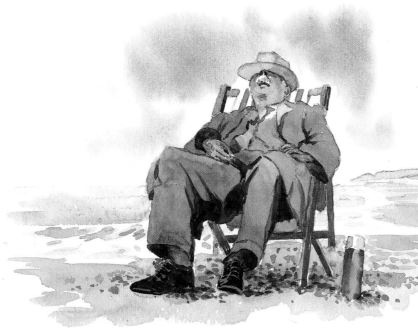

◀ I could not resist this figure. Based on a sketch of a man in a deckchair from another source, I placed him on the beach in the warm sun.

▼ Watch the way people move: when viewed from behind, walking figures appear to have one leg shorter than the other.

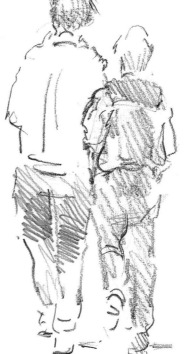

When you don't want to go to the bother of taking your paints out, you can make an instant palette at the end of your sketchbook. Using either tube watercolours or watercolour pencils, paint thickly or scribble hard with your pencils to make some squares of colour – red, yellow and blue will suffice. These can then be used by moistening with a brush and a little water or even saliva.

Sketching movement

Some people find it difficult to know where to start when drawing figures, especially if they are in motion. As with all other subjects, getting to grips with this is a matter of close observation and noting some useful guidelines.

When a figure is standing, the weight runs in a straight line from the head to the leg which is bearing the weight. Hold your pencil straight against the head to see which this is. Very rarely do we stand with the weight equally distributed to both feet. When you draw be aware of this and make sure you have the weight on one foot to make your figure look natural.

When people run the limbs are extended, and usually the head is thrown back to open the chest as more oxygen is needed. If they are running very fast, there is a slight disjuncture between the shadow and the feet.

If a figure is walking away from you, one leg appears shorter than the other. The head is in front of the shoulders, which means the neck is rarely seen because it is hidden by the movement of the shoulders. When the figure is walking towards you the head is also in front of the shoulders, and by the action of walking the neck again is not usually seen. The shoulders appear from behind the head about level with the ears.

PAINTING GROUPS OF PEOPLE

You can sharpen your sketching skills at home by observing passersby. A big advantage to working indoors is that you don't gather the small crowd of onlookers enjoying the spectacle of the artist at work which can be quite offputting for the outdoor painter. Likewise, your subjects will be going about their business unconcerned by your attention.

These sketches will be a valuable resource from which to make paintings. You can incorporate your figures into all sorts of different contexts, and by using your imagination when it comes to their dress you can make them of any nationality and occupation that you care to.

When you draw, note the way light falls on the figures and where the shadow appears on the ground as they walk. Shadows anchor figures to the ground. They are usually thin, elongated shapes as a result of perspective.

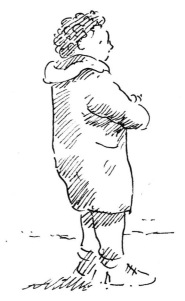

▶ *Drawings of figures from my sketchbook. The girl kicking a ball was reversed in the painting on the facing page.*

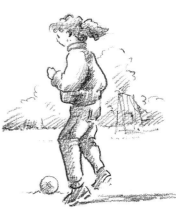

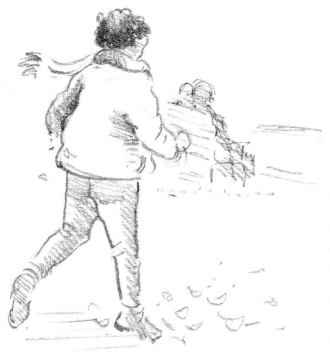

Adapting sketches

When you decide to make a painting from the figures in your sketchbook, you can bring in as many from different sources as you choose, altering them slightly if need be for the sake of a pleasing composition. You may need to reverse them to assemble them into a group or to prevent a figure looking out to the side of the painting and thus directing the viewer's eye also out of the frame. The easiest way to do this is to simply trace over the drawing and then reverse the paper. Remember to make the direction of the light consistent throughout the group.

With small groups, using odd numbers rather than even gives a more harmonious effect. Rather than a group of four figures, for instance, use three or five.

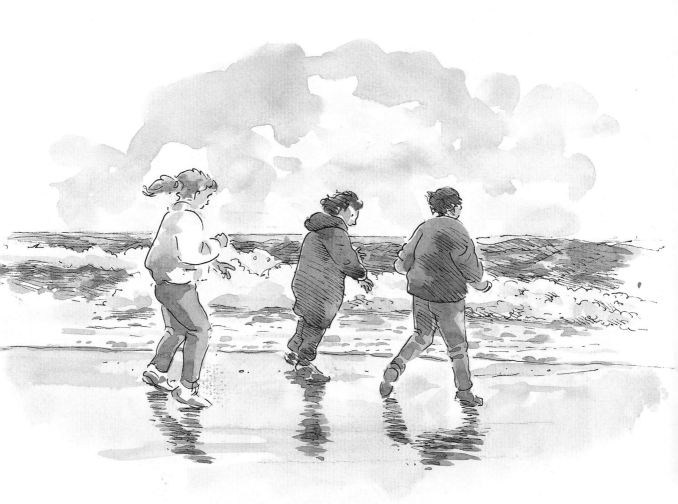

▲ Chasing Waves
15 × 24 cm (6 × 9½ in)

These children playing on the shore came from different sources recorded in my sketchbook. I chose wash and line in order to convey a light, airy feel to the scene, with incisive pen lines enhancing the feel of a blustery sunny day.

PROJECT

PAINTING PEOPLE

- Make some sketches of passersby, choosing a range of movement and observing the direction of light and cast shadow.
- When you have made a few, try putting them in a new setting and painting them. Select some backgrounds from photographs and let your imagination go. They might be strolling in the country, part of a sports crowd, a single traveller in a desert, spacemen or historical figures. There is no limit to the number of times you can employ the same figures in different groupings and with a range of backgrounds and clothing.

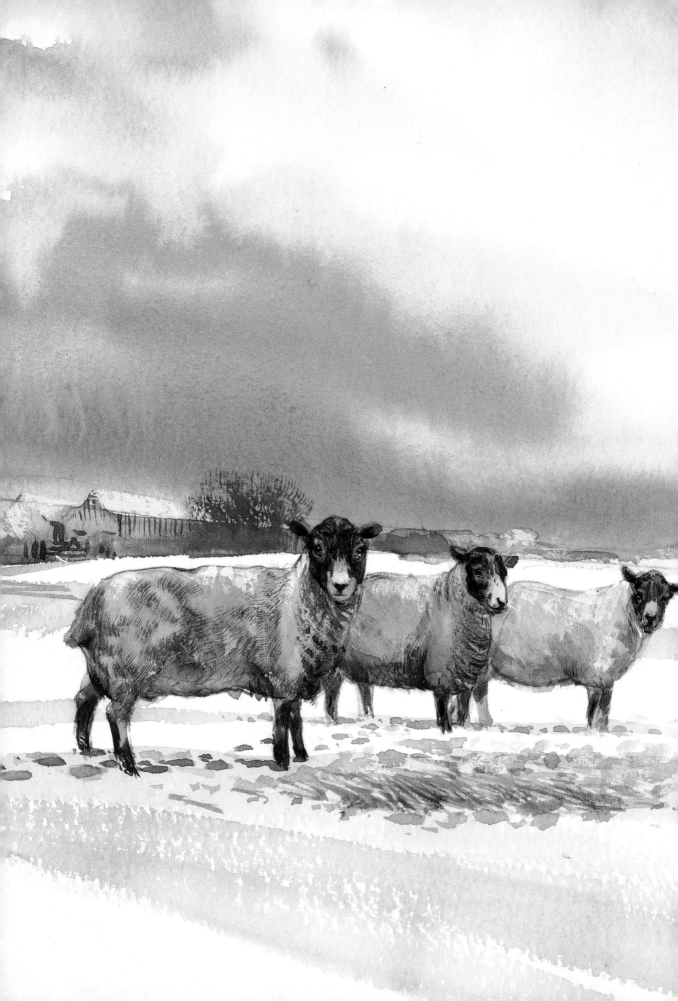

Painting Animals

Animals make good subjects for painting, and the most obvious subject may be the pet in your home. If you don't have one, or it is a very uncooperative model, you can paint friends' pets or use photographs. Small-scale toy model animals can also be invaluable to the indoor painter, particularly one who wants to paint farm animals.

Television and videos can bring you any kind of animal model you could wish for, with programmes ranging from wildlife to the temporary occupants of a vet's surgery. Many artists are attracted to the excitement of fast-moving animals, and videos will allow you to watch an animal in motion as many times as you need to understand the mechanics of its movement.

◀ Sheep in Snow
28 × 38 cm (11 × 15 in)

The sheep in this painting were adapted from farmyard models and a photograph. Unlike live animals, models have the advantage that they can be placed in any position to suit your composition.

PAINTING YOUR PET

Like people, every animal has its own particular character, as anyone who has shared their home with a pet will agree. Whether yours is lively and outgoing or more placid and calm, this needs to be reflected in your painting in order to capture a likeness that will elicit affectionate recognition. If you are drawing someone else's pet, ask the owner about the animal's character so that you can concentrate on that aspect in your sketches. Sometimes a series of small studies can sum up the character of the animal better than one painting, so consider this option too.

Don't be surprised if your model becomes restless and even tries to disappear. Animals, and particularly birds, hate being stared at, which makes it rather difficult for the artist. You may have to resort to asking a friend to occupy your model's attention, perhaps by giving it titbits or toys. As a last resort, you may need to back up your drawing with a photograph if things get difficult.

▲ *When you are drawing a bird an egg makes a simple construction shape to start with. You can then add wings and tail feathers on to this shape.*

▶ *A good opportunity to catch animal models motionless is when they are sleeping. My cat Guy does it a lot.*

▶ *Max is a Burmese with a very definite character. This is one of his typical poses, looking down on life from a perch on a bookcase.*

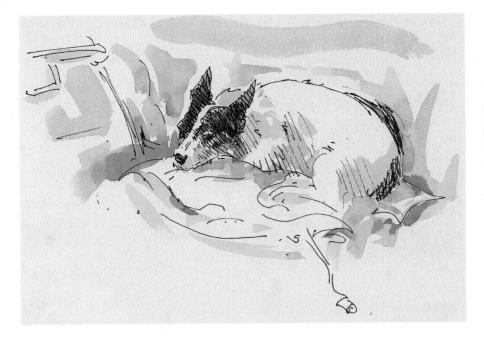

Painting dogs

The main problem with dogs is that they tend to want to see what you are drawing and to join in too. Try to provide something to occupy them so that they don't notice you – maybe a toy or a bone will help. If you are having real trouble and cannot get the dog to sit still, then a photograph may be the only answer.

You will probably have to work fast, in which case you need to know what to look for. As with other subjects, aim to reduce the shapes you see into simple geometric ones such as spheres and tubes. This will give you a sense of the volume of what you are drawing.

◄ *A series of quick studies is ideal for a lively litter of puppies.*

PROJECT

CAPTURE YOUR PET'S CHARACTER

- Make a drawing of your pet, concentrating mainly on capturing its character rather than getting the physical details right.
- Without making your pet resemble a cartoon figure, consider how it might look if it were a character in a children's book.

- Think about your pet's character: is it quiet or lively, mischievous or solemn? A tip to help you to decide upon your pet's character for this purpose is to imagine it as a human being. What sort of person do you think it would it be?

FARM ANIMALS

What do you do if you want to paint a farm animal but don't have enough knowledge to do it with confidence? The answer lies in your local toy store or a specialist model shop. I still sometimes use a set of toy farm animals that I played with as a child. Made of metal, they are quite good reproductions of the real thing. The great advantage that models have over photographs is that their form can be observed by turning them to any position you require. It is important to place them in correct relation to your eye level as you would see them if they were real. In most cases, that will be slightly below your eye level.

You can arrange the models in the lighting of your choice. A spotlight or desk lamp can represent the sun and will render clear shadows, which are vital in order to create solid form.

▼ In this study of a cow drawn from a model the form is a little sturdier than a real cow's. Allow for this when you draw from a model by breaking the outline slightly and tapering the legs.

◄ When drawing this frontal view of a horse I was careful to place it on the correct eye level as seen from the ground.

▼ I scribbled in the tones of this composite group to gauge the tonal weight, an important factor in picture-making.

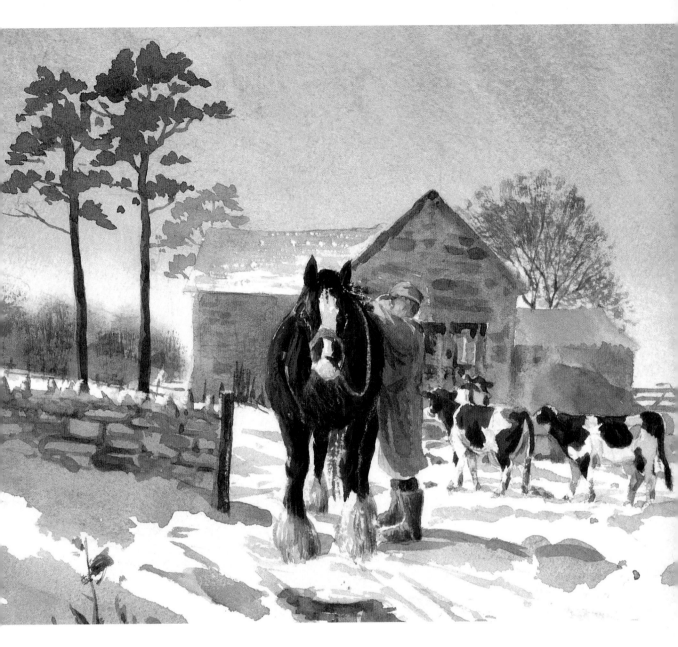

Setting animals in the landscape

When you are working from model animals you will need to avoid reproducing their static quality and to breathe life into them as you draw. You can achieve this mostly by using broken lines, which suggest movement.

Placing them in a landscape setting, taken either from a sketch or from a photograph, will also help you to make them look more real. In order to gauge the relative size of the animal when you are adding it into a scene in a photograph, imagine it standing alongside the nearest tree or fence. Note the direction of the light on the land before you begin work on the animals and make the lighting on the models compatible.

▲ Winter Morning
24 × 26 cm (9½ × 10½ in)

For this painting I used models of cows and a horse in different positions and re-created them in a landscape setting by adapting a photograph into a composition with animals. Because the horse was alone at the front of the painting I decided to add a figure to the group to give it balance.

CAPTURING MOVEMENT

The fascination of painting animals is the way they move and the sheer speed that some of them are capable of commanding. There is a great desire on the part of artists to capture their movement, which requires keen observation and much sketching. A good way to work your way into this is to remember part of a movement each time you get an opportunity to observe an animal. Television is a great boon here. There are numerous wildlife programmes and videos available, so make use of them for studying and sketching.

Almost all animals have three important areas of articulation: the junction where the base of the neck meets the shoulder; the junction between the shoulder and the belly; and the spot between the belly and the hindquarters. These are the areas that dictate the pose and the swing of the body as it moves. Watch these areas in particular each time you are studying an animal in motion. Finally, remember that whichever way the head points, the rest of the body follows.

Capturing movement can be as much about what you leave out as what you paint. If the animal is moving fast, the eye cannot pick up the detail of the legs. It sees only a blur, so paint only some of the animal. Speed of movement may also be suggested by a slight disjuncture between parts of the limbs, or a cloud of dust kicked up by racing feet. If you are painting in watercolour, use wet-into-wet technique to suggest a blur of action.

▼ Round-up
15.5 × 24 cm (6 × 9½ in)

The movement of this cattle herd is implied by the swirling dust, which was portrayed by using a wet-into-wet technique with watercolour.

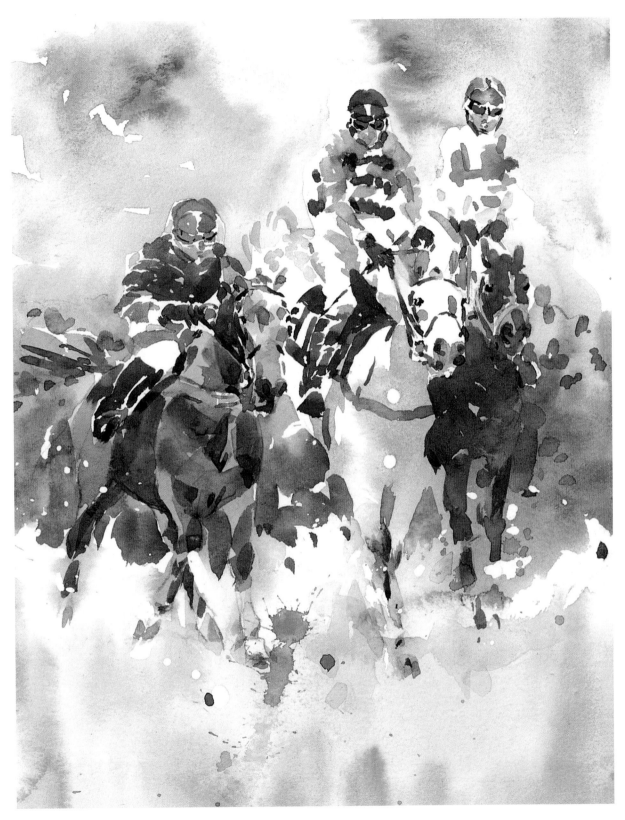

▲ Steeplechase
20 × 16 cm (8 × 6½ in)

Leaving slight breaks in the horses' legs and using spatters of masking fluid and paint helped me to suggest vigorous movement in this watercolour painting of a steeplechase.

WORKING BIG, WORKING SMALL

Varying the size of the subjects you paint can inject fresh impetus into your work and you will start to see possibilities for a painting you might never previously have thought of. Tiny objects painted larger than they are, or magnified close-ups of part of a plant, for example, become fascinating studies in shape and colour.

Maybe you would like to paint large-size, using a roll of paper pinned to a wall to make your picture. At the other end of the scale you could try your hand at painting miniatures, following an artistic tradition dating from the 16th century.

◀ Filigree Brooch
(Detail)

Here I picked out a piece of intricate jewellery and enlarged it to explore the richness of its detail.

THE BIG PICTURE

Instead of painting your subject as part of a larger composition, try a close-up view. Close-ups were inspired by photography, and one only has to look at the work of artists such as the American painter Georgia O'Keefe (1887–1986) to see the effect the camera has exerted on painting. If you are becoming bored with conventional still-life arrangements, this fresh approach will bring plenty of inspiration. Even the vegetable rack will provide exciting patterns, colours and textures. Try painting a cut cabbage, the inside of a fig, a pomegranate, a walnut half, a tomato and a cut sweet pepper to see the absorbing new range of ideas that has opened up to you.

Enlarging your scale

Even when you paint close-up views, you do not necessarily have to produce small-scale work. If you feel your work is becoming niggly and your painting lacks spontaneity, go for the bigger picture.

First find a wall on which to attach your paper. If you do not have enough unadorned wall, a door will do as long as it is not panelled – you can stick the paper to the top of the door and roll it down to the floor. Buy a roll of paper (wallpaper lining paper is reasonably good and not expensive), some tube paint, a large brush and something to draw with such as a wax or oil pastel, and away you go.

Drawing and painting on a grand scale is very good for your style. You have to stand, or at least to stretch your arm to draw and paint. Doing this frees your hand and arm so you move them both rather than just your wrist, allowing you to produce freer, more spontaneous brush marks. In fact, if you always stood to paint, your style would improve immeasurably.

You will have to contend with gravity, which will cause the paint to drip or run. Counter this by using thicker paint if you don't want runs, or controlling them if you do.

◄ Pepper
12 × 13 cm (4¾ × 5 in)

This pepper has a cave-like interior – a possible inspiration for an imaginative painting.

▶ Tiger
104 × 52 cm (41 × 20½ in)

This painting was done on wallpaper attached to a door. Drawing and painting on such a magnified scale makes for a very spontaneous and free style.

SMALL IS BEAUTIFUL

Creating the small paintings known as miniatures is fascinating. Watercolour is used on top of an ivory-like surface, with every brush mark carefully laid or stippled and the whole painting built up with individual marks. As a rule washes are not employed.

Miniatures used to be painted on ivory or vellum, or prepared card; Nicholas Hilliard (1547–1619) painted his famous portrait of a gentleman leaning against a tree on the reverse of a playing card which had been prepared by sticking parchment on the surface.

Ivorex is the modern equivalent of ivory and has the same translucent surface. This allows a small amount of light to shine through and the colours are kept transparent. Luckily Ivorex is forgiving as a ground for painting in that it can be wiped clean if the painting doesn't work out.

Historically miniatures were developed as portraits, and could even be mounted into a piece of jewellery as a memento of a loved one. Since the invention of photography portrait miniatures have become somewhat redundant, and this has freed the genre to

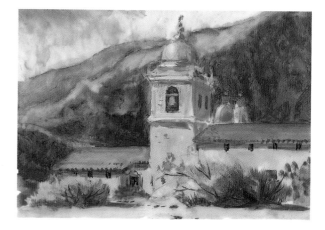

▲ **Californian Mission**
6.5 × 9.5 cm (2½ × 3½ in)

This miniature landscape was painted on Ivorex, using watercolour.

depict almost anything. Landscapes and floral subjects are popular, though portraits are of course still painted for their ability to imbue a sitter with more than can by expressed by a photograph.

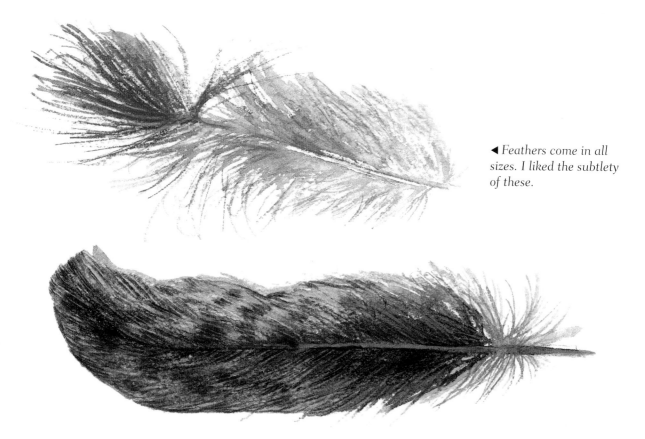

◀ *Feathers come in all sizes. I liked the subtlety of these.*

◄ *Glass marbles with their twists of colour and reflected light make fascinating subjects for an artist.*

Something small, something different

When it comes to finding small subjects, there is no limit to what you can choose. Aim for interesting colours or textures that will encourage the viewer to study your picture closely.

Marbles are wonderful to paint: the colours twisted into these glass globes are quite beautiful, and they come in many sizes. A small dab of plastic putty will ensure that they do not roll away while you are painting them. Feathers, with their range of subtle colours and tones, also make excellent subjects.

Other good choices include ornate buttons, pieces of jewellery, large beads with interesting textures and intricate patterning and elaborate hair ornaments. If you look around your home you are sure to find subjects to inspire you, whether they are in your jewellery box, your dressing table or your sewing kit.

Working with small objects can give you great confidence as you paint them. Their diminutive size makes them seem more manageable and approachable than larger ones, even if they are in fact quite complex.

PROJECT

PAINT SOME SWEETS

- Raid your nearest sweet shop. There is a wealth of subject matter out there, and you have the added bonus of being able to eat it afterwards!
- Pick out the sweets with the most interesting colours and arrange them in a composition, either in profile or looking down on them. You will get the most colour impact if you place them on white paper – use a piece of smooth watercolour paper or thick cartridge paper. Light them with a lamp for maximum light, colour and shadow.
- Draw them out first then paint them. If they are very brightly coloured, use pastels or inks to add intensity of hue.

▼ *Sweets make delightful subjects to paint and come in a good range of colours and shapes.*

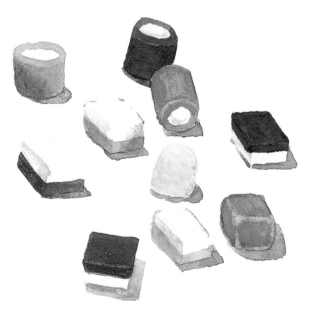

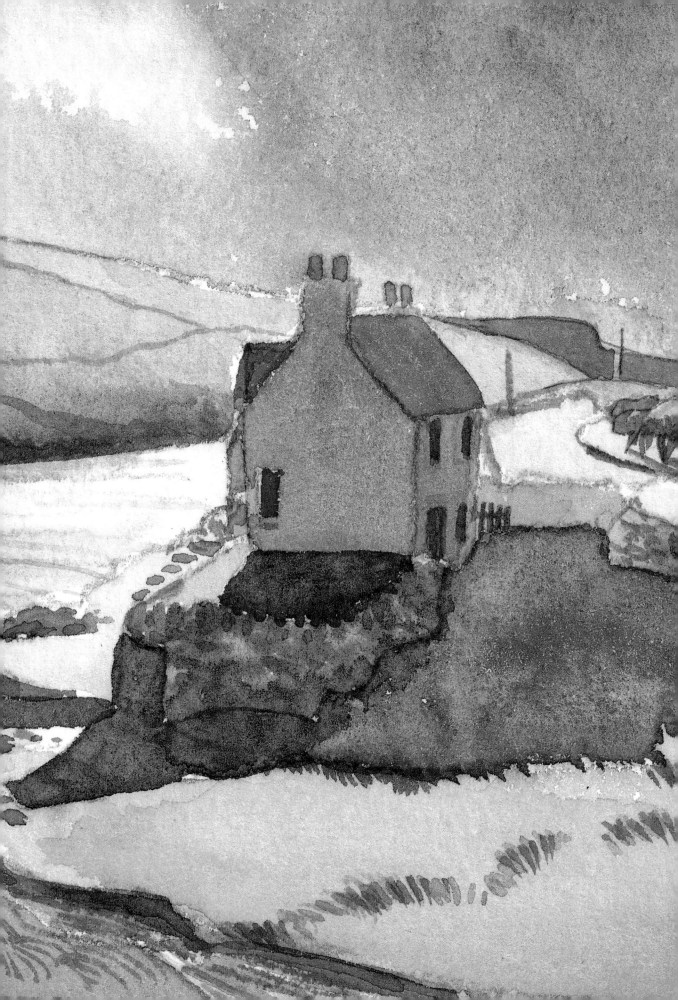

EXPLORING COLOUR

Through your handling of colour you will be able to experience the greatest pleasure and excitement in your painting. You can use it to promote drama, with vivid colours and strong contrasts, or to explore the beauty that can be discovered in a restricted, subtle palette.

Learning to make the most of colour temperature is an important part of your art, since warm and cool colours not only evoke emotional responses but also create a sense of distance as they appear to advance and recede respectively. You will find that manipulating colours both to express your feelings about your subject and to arouse a similar response in the viewer is an absorbing part of picture-making.

◄ **House by a River**
12 × 20.5 cm (4¾ × 8 in)

Using colour expressively helps to transform the subjects you paint. I increased the colour values of this watercolour landscape in order to make it more interesting.

USING LIMITED COLOUR

The subtlety and beauty of using just a few colours is often ignored – a paint box with more than a dozen tempting pans appears to offer many more exciting possibilities. Yet great watercolourists such as Thomas Girtin (1775–1802) used only five colours. Try some limited colour selections for yourself and see just what you can achieve. A selection of three primary colours (a red, yellow and a blue) will produce almost everything you need and will also help you learn more about colour mixing. To stretch yourself further, choose three variations of the primary colours that you don't often use. All the colours mixed will relate to each other, creating a more cohesive painting than comes from using a wider palette.

▼ **Venice**
24 × 34 cm (9½ × 13½ in)

In this painting I used only Indigo and Raw Sienna, choosing a warm and a cool colour to give balance to the painting. Between them they created a surprising amount of tonal and colour variety.

▲ *A monochrome interpretation from a colour photograph, here painted in Warm Sepia, teaches you about tone as well as making an interesting painting.*

▲ Delft
14 × 15 cm (5½ × 6 in)

This painting of a Dutch town uses only the three primary colours, in this case Alizarin Crimson, Phthalo Blue and Raw Sienna.

Working in monochrome

It is of course possible to use just one colour, known as painting in monochrome. Employing a colour photograph as reference, paint a picture in different tones of a single pigment. The effect is quite striking, and easy to do as long as you concentrate on tone rather than colour. It is also a useful exercise in learning about the value of tone, allowing you to see the balance of light and dark distributed throughout the composition.

PROJECT

PAINT A PICTURE IN TWO COLOURS

- Find a photograph that has a good range of tone. Squinting at a photograph or subject through half-closed eyes helps to eliminate colour and allows you to see tone instead.

- Choose one colour capable of strong, dark tones and one that is bright to get the full range of tonal values.
- Experiment with new combinations of colours. Some pairings

to try are Raw Sienna and Indigo; Cadmium Red and Viridian or Hookers Green Dark; Rose Madder or Alizarin Crimson and Yellow Ochre; Phthalo Blue and Burnt Sienna.

WARM AND COOL COLOURS

Judicious use of warm or cool sets of colours can make a major contribution to the success of a painting. All three primary colours lean towards warmth or coolness, and you can choose to establish a balance or emphasize one or the other, for example to paint a Mediterranean scene or a wintry landscape.

Cool primaries include Lemon Yellow (inclines to green); French Ultramarine (inclines to cool red); and Alizarin Crimson (inclines to blue). For warm, try Cadmium Yellow Deep (inclines to orange red); Manganese Blue, Coeruleum and Prussian Blue, which incline towards yellow-green; and Cadmium Red and Vermilion, which incline to yellow.

Judging the colour temperature of a mix

The use of colour temperature is invaluable when you are painting landscapes since cool colours recede while warm colours advance, thus playing a major part in establishing a sense of distance. It is not

▶ *Warm versions of the three primaries: Cadmium Yellow Deep, Cadmium Red Pale and Prussian Blue.*

▼ *In this scene I used the warm colours Burnt Sienna, Cadmium Yellow Pale, Manganese Blue, Phthalo Blue and Cadmium Red.*

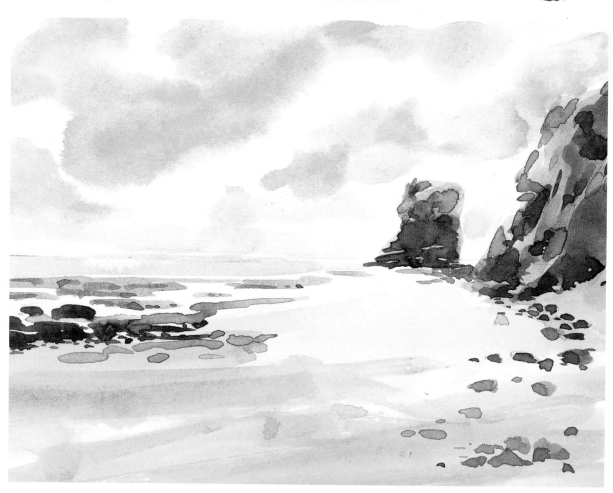

difficult to discern the colour temperature of a primary colour, but when it comes to mixing colours things are not always so clearcut. The best way to judge is to look at the primary colour that is in the mix, for this will often indicate whether the colour is warm or cool. For example, if an olive has high proportion of warm yellow in its mix then the resulting colour will be correspondingly warm.

▲ *This olive colour (known as a tertiary colour because three colours were mixed) is a warm colour because I used more warm than cool colours in the mix. The colours were Cadmium Yellow Deep (warm) with Cadmium Red (warm) and French Ultramarine (cool).*

◀ *Cool versions of the three primary colours: Lemon Yellow, Alizarin Crimson and French Ultramarine.*

▼ *This beach scene was painted in cool colour mixes. I used French Ultramarine, Alizarin Crimson, Lemon Yellow, Raw Umber and Sepia.*

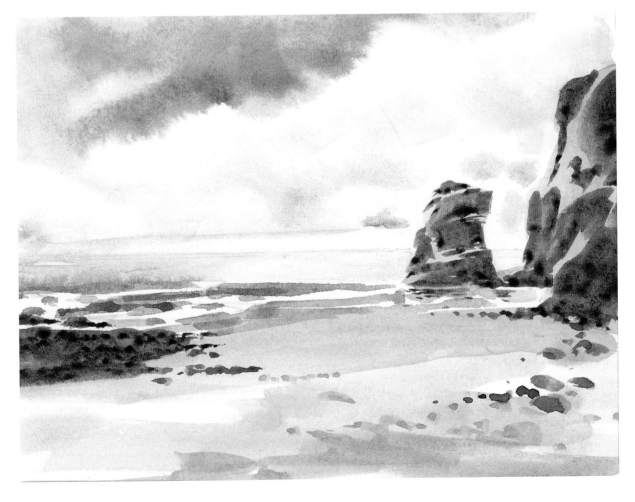

EXPRESSIVE USE OF COLOUR

It is well known that colour has an emotive effect, and indeed it is consciously employed by the advertising industry to persuade the target audience to buy the product. You too can use colour to express how you feel about what you are painting and to transmit that to the viewer.

This style of painting reached its height in Expressionism in the early part of the 20th century. In this movement, said to have derived from Van Gogh (though never articulated by him), simplified line and exaggerated colour were used to depict the artist's response to the subject. Expressionist artists include the Austrian painter Oskar Kokoschka (1886–1980) and the French painters Georges Roualt (1871–1958) and Franz Marc (1880–1916), who employed colours which had a significance for them rather than restricting themselves to the reality of objects.

Painting in the Expressionist style

Paint some pictures in which you convey in colour how you feel about a subject. You can use

▲ *This simple landscape, painted with just three strong colours, effectively conveys a hot summer's afternoon.*

▼ Portugal
35 × 55 cm (13¾ × 21½ in)

I chose a watercolour palette of bright blues and yellows to depict my feelings about a blustery sunlit afternoon on the Atlantic coast.

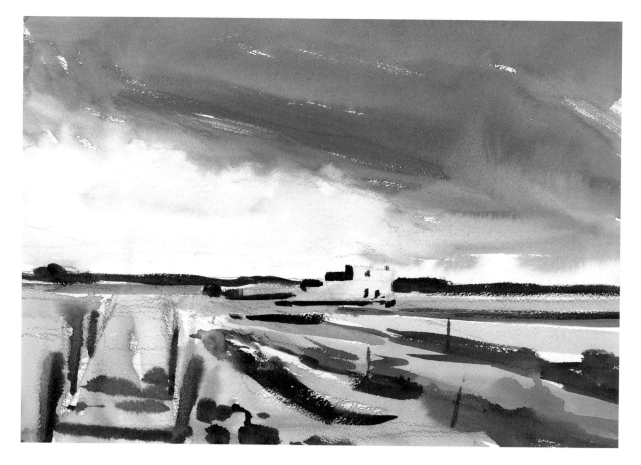

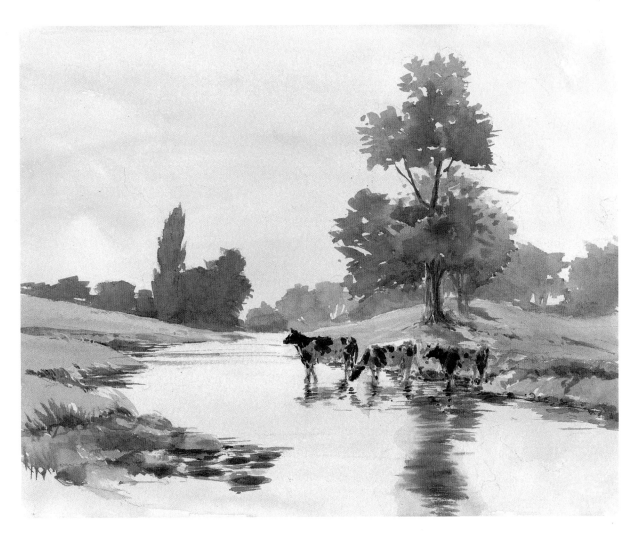

▲ Cows in the River
▲ Cows in the River
27 × 36 cm (10½ × 14¼ in)

For this pastoral landscape I used soft, muted colour to convey the calm and tranquillity that was my response to the subject.

photographs as reference. As a contrast, you could paint one that suggests quiet and calm through the colours you use, while in the other, you might want to depict something more exciting. Begin by making a list of colours that you think match your feeling. Red is generally thought of as being an exciting colour, although some reds can be sombre or, mixed with other colours, very subdued. The colour blue might suggest restful quiet, but it can also be strident and energized.

If you feel a little intimidated by the idea of letting yourself go, treat working in this way as merely an exercise. This will enable you to feel free about taking risks with your painting, and you will find it very liberating to follow what your emotions dictate rather than trying to mix a colour that describes an object as closely as possible. Even if you ultimately decide that this style of painting is not for you, you will have learnt a lot about colour in the process of discovering that and your picture-making will be enriched by the experience.

CREATIVE & EXPERIMENTAL TECHNIQUES

In this chapter it is a positive advantage to be indoors, where you can play with your media and experiment with different techniques for as long as you want. You can paint colours to music, adapt the methods of the great painters of earlier centuries to a modern theme or explore abstract painting; try illustrating a children's book, allowing your imagination to run free in the realms of fantasy; work with gouache and ink to make a painting resembling a print; and begin keeping a seasonal diary, which is a good way to encourage you to pick up your brushes regularly.

If you have limited yourself to strictly representational work so far, this is the time to take the plunge and strike out for unknown shores.

◀ **Red Abstract**
26 × 35 cm (10½ × 13¾ in)

*In this watercolour painting I indulged in pure colour and painted to music –
Mozart's Flute Concerto No. 2 in D.*

LEARNING FROM A GREAT PAINTER

As a student, I learnt some of my most valuable lessons from copying works by Dégas (1834–1917) and Géricault (1791–1824). From the former I gained knowledge about the arrangement of shapes in a painting and the application of oil paint, and from the latter I learned about modelled form, tonality and use of contrasts.

The work of J. M. W. Turner (1775–1851) has impelled many artists to paint in his style. Since his wonderfully free watercolour studies of Venice have always inspired me I decided to make a painting that drew on his technique. His limpid washes of a sky reflected in the lagoon during a century as yet undisturbed by vaporetti could, I thought, be transposed to a modern setting of chemical works on the river near my home.

There is very little account of how Turner actually painted his watercolours. He certainly worked his watercolour sketches very freely in a manner we find highly attractive today, though at the time it was thought unconventional and unfinished. Once he was observed pouring water onto a painting, presumably to keep the paint moving on a wet surface, and he often worked on several paintings at the same time.

The colours he used were Chrome Yellow, Chrome Lemon Yellow, Chrome Orange, Cobalt Blue and Emerald Green. Mars Red was also in his palette, and later Vermilion and Ultramarine. These were not always stable colours, however, and some of them have altered over the course of time.

▼ J.M.W. Turner, Venice: Looking East towards San Pietro di Castello – Early Morning, 1819
22 × 29 cm (8½ × 11½ in)

Turner's painting of Venice in an earlier age acted as a guide as I undertook a modern version.

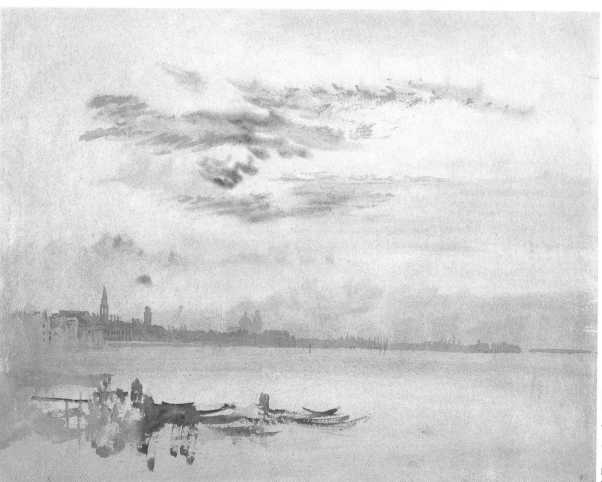

Making a painting with Turner's technique

I used cartridge paper, since a lot of Turner's watercolour sketches were painted in his sketchbook on smooth paper. It seems he used clear glazes of colour one over another, some wet-on-dry, others wet-into-wet. I tried this first to see how a wash and glaze worked on cartridge paper.

After sketching out the composition in pencil, as was Turner's practice, I washed over the whole area with Lemon Yellow. This was medium in tone, for when you are glazing the first colour needs to be the strongest. Before it dried I added in Vermilion (Hue) near the horizon and down across the lower half of the painting. To make red clouds, I threaded in some stronger streaks of the same colour above the horizon.

When this was dry I washed over the middle part of the painting with a damp brush and water and painted a band of Cobalt Blue on the top which diffused into the wetted area. Adding more water, I then graduated the blue down to the bottom to become the water and shore. Once it was dry I added the buildings, together with some smoke. Foreground detail on the shore was put in wet-on-dry with a mix of Cobalt Blue, Vermilion (Hue) and a little Lemon Yellow.

▲ *In these trial pieces I used a wash of Lemon Yellow with Vermilion (Hue) mixed into it. I added Cobalt Blue when the first wash was dry.*

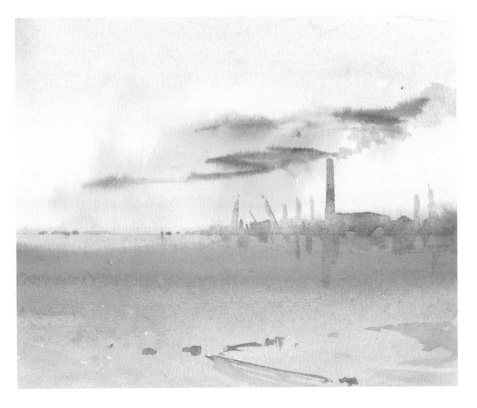

▶ Inspired by Turner
12 × 17 cm (5 × 6¾ in)

The completed painting of an industrial site on a river, inspired by Turner's working methods. Only three colours were used: Lemon Yellow, Vermilion (Hue) and Cobalt Blue.

KEEPING A SEASONAL DIARY

Use the passing of time to keep a visual diary. Even if you cannot go out, there will be opportunities to note the changes in the natural world outside your window. You may wish to paint the smaller, more intimate things of life – one or two seasonal flowers, fruits and seeds or a feather. Times of day and the changes of light could also be a good idea as a seasonal diary project. Maybe you could record people in your family, particularly young children who will change a good deal in a year. Sometimes you may want to document your reactions in paint or pencil to the bigger events going on in your world; news items in papers or on television may compel you to a personal response.

You are unique as a person, and what you choose to record will be individual to you. Like written diaries, visual ones are your voice alone. Diaries fascinate future generations and yours will too. Even if you think your painting skills could do with improvement, it's not important; your diary will mark where you were at a particular time and your reaction to what you saw.

◄ *Spring: I spent a chilly hour recording these snowdrops.*

▲ *Spring: I matched the fragile quality of these flowers with a china cup.*

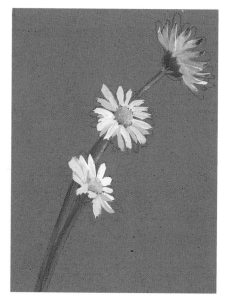

▲ *Summer: I painted these buttercups and daisies (right) on coloured pastel paper to enhance their colour and shape.*

▲ *Summer: The colour of this poppy speaks of hot days.*

◀ Autumn: The glossy browns and pale greens of conkers were a pleasure to record.

▶ Autumn: I painted these mushrooms before gathering them for breakfast.

▲ Winter: These nimble squirrels were recorded while they paused to eat.

▶ Winter: The delicacy of pale snow on sharp, dark holly made a good contrast.

ILLUSTRATING A BOOK FOR CHILDREN

There is a tendency to think that illustrating for children is easy – just a matter of simple figures in bright, cheery colours. In fact, it is as complex and actually more difficult than painting a picture. Nevertheless, it is great fun. You can invent a whole new world and make your characters be and do anything, taking you into an exciting realm beyond your own.

Many people tend to believe that they simply do not possess sufficient imagination to do this. Actually, imagination is nothing more than the putting together of the familiar in a new and different way.

▶ *Keeping the forms simple can still make a suitable illustration.*

▲ *Altering the size ratio of objects gives a picture new meaning.*

For example, try altering the scale of things in your picture so that an animal or human is bigger than a building. In this fantasy world, you can also depict animals or even machines doing human things.

If you are stuck for inspiration, try illustrating a fairy story, or adapt the plot of one and update it. The rules of copyright prevent you from using the text of modern books and from copying the work of another illustrator, but old fairy tales are there for you to use as you will.

▶ *In the world of illustrating for children, machines can be characters too.*

Setting to work

Either line and wash (pen first followed by colour) or wash and line (painting first and then adding pen lines) makes a good medium for illustration. Whichever method you use you can draw out the picture in pencil first.

In the case of a picture book where there is little text, you have almost the whole page for your illustration. You need to think first what you want to say in picture form, and whether landscape or portrait format will be best suited to your subject. Is this the beginning of the book, where your character is introduced? Do you want to show what sort of person your character is, and if so how can you sum these things up in a picture?

These are the things I ask myself before I start. If it is a story about an animal it helps to think about what sort of person that animal would be if it were human. This is a good start to establishing character and keeping it consistent.

In the illustration shown here I wanted to establish the main character of the cat in relation to his world – a small village. This meant showing quite a complex composition with plenty going on. I saw the village as a panoramic beginning after which, as the pages turned, I could close in to focus on the cat himself.

▲ *Here the cat is seen in relation to his home – a small country village.*

PROJECT

ILLUSTRATE A CHILDREN'S STORY

■ Write a story and illustrate it. Keep the character simple, since you will need to paint it more than once and this should not become a chore.

■ If you are stuck for an idea use a fairy story or fable that you can go on to adapt if you invent variations in the plot or characters.

■ Choose an existing book size to work to – it will give you a structure that has been proved to be successful.

■ You can print out the text from your computer, if you have one. If there is not much text and your handwriting is attractive, you can make a handwritten book which will have a pleasantly informal feel.

COLLAGE

In this collage of a sailing boat the gaps between the torn paper help to suggest the liveliness of the windy conditions.

I find collage a great alternative to painting when I need a change. It forces me to simplify what I see and how I depict it, and I like it to be satisfyingly messy. Described here are just three of the many ways of doing collage. The equipment is minimal: scissors, glue (preferably one that dries clear, such as PVA), a craft knife and some sturdy cartridge paper.

A magazine collage

Collect a few glossy magazines and travel brochures that have a good selection of colours. Choose a subject you want to depict and draw out your picture on the cartridge paper.

Tear, rather than cut, pieces of coloured paper from the magazines to match what you need. Stick these into position on the picture. Tear and stick as you go otherwise you risk ending up with numerous bits of coloured paper with no idea where you intended to place them. Don't worry if there are slight gaps between colours – your collage will look more interesting that way. When you have finished the collage you can varnish it to seal the surface.

◀ **Italian Bay**
19 × 25 cm (7½ × 9¾ in)

I made this collage by painting watercolour paper and then cutting it. With this technique it is possible to produce subtle colour changes.

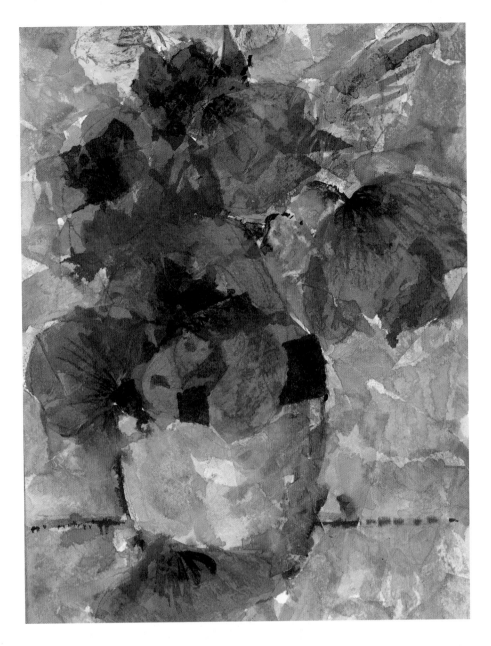

► **Full Blown**
45 × 28 cm (17¾ × 11 in)

*Torn tissue and inks
create a surface
resembling batik. This
method produces rich,
jewel-like colours.*

Watercolour collage

With this technique you can either use a failed
watercolour or prepare watercolour paper by laying
colour on it first.

Find a subject to use and draw out your picture on
cartridge or coloured paper. Cut your painted
watercolour paper into shapes (watercolour paper
does not tear well) and stick them into position. With
this method, overlapping them slightly works better
than leaving gaps. Don't varnish this collage, but
protect it behind glass if you are framing it.

Tissue-paper collage

This method makes wonderfully vibrant collages. In
addition to your basic tools you will need some tissue
paper of the sort sold for craft-making and coloured
drawing inks.

Decide upon your subject and draw it clearly on
stretched cartridge paper or on white mounting
board, which is a good alternative for this method.
Tear the paper into small (but not tiny) pieces and
stick them all over the paper surface. The pieces can
overlap slightly.

Using coloured inks, which can be diluted for paler
tones if you wish, paint your colour onto the surface.
As the ink creeps under the tissue it wrinkles it,
producing a batik-like effect. Build up the clear
colours to the strength you need. You can add pen
lines with care if needed. When it is dry, you can
varnish the collage and, ideally, hang it behind glass.

MAKING A SIMPLE ABSTRACT

Making an abstract is a very good way of defining what it is you want to say in a painting, and that is profoundly important in your work as an artist. To abstract means to take away, and to imagine the concept applied to a painting, think of making an essence from a sauce or stock; the liquid is boiled until it loses its superfluous water, leaving a strong, flavourful liquor behind. There is a fascinating series of paintings by the Dutch artist Piet Mondrian (1872–1944) in which he moves from a painting of an apple tree into a set of abstract shapes and lines that are the essence of the tree. His style, known as Neo-Plasticism, consisted of restricting lines to purely geometric shapes coloured with the three primary colours of red, blue and yellow together with black, grey and white. Elements are gradually withdrawn until what is left is the essence of a subject.

There are all sorts of ways of arriving at an abstract, and as many terms to describe them. You could choose to work primarily with colour and use it in an Expressionistic way. Take a look at the paintings of the Russian-born American artist Marc Rothko (1903–70), for example. Rothko was an Abstract Expressionist, using colour only in order to convey its feeling. He painted huge canvases of one or two formless colours often merging into each other, and his work has been described as 'dull fire'.

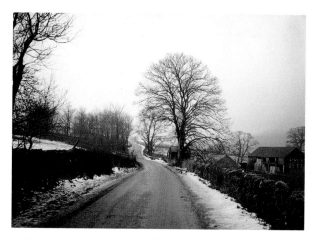

▲ *The strong diagonals and contrasting tones suggested to me that the image in this photograph could be developed as an abstract.*

Alternatively, you could work with symbols in the manner of the French Symbolist painter Odilon Redon (1840–1916). He used recognizable objects such as vases of flowers combined with fantastic nightmarish motifs.

Step by step to an abstract

This simple exercise, based on gradually abstracting elements in the manner that Piet Mondrian did, will help you to work out what is important about the subject you are tackling.

▼ *Step 1: I chose a photograph of a winter scene as a starting point for my abstract painting. From this I made a first drawing in pencil, isolating the major shapes of the building, trees and walls. Next I made a tracing of this drawing.*

▼ *Step 2: I transferred the tracing to a fresh piece of paper but began to extend the lines to make stronger, more geometric shapes. Keeping the lines straight increased the feel of wintry starkness. The drawing was becoming a mosaic of angular shapes.*

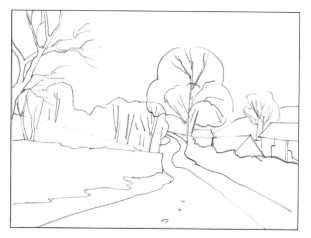

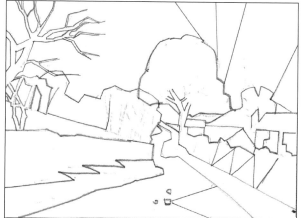

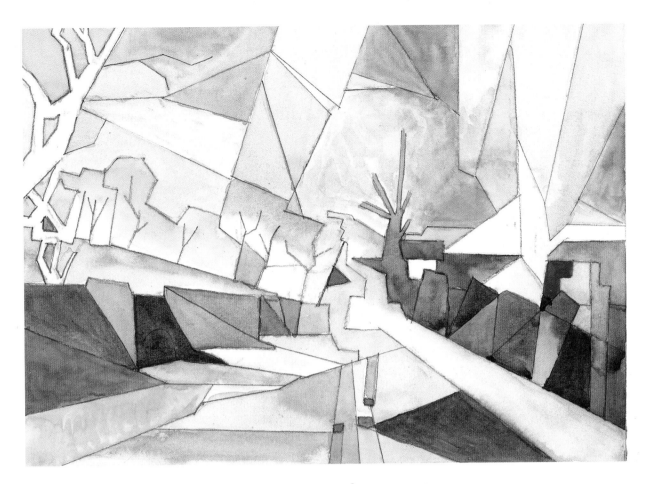

▲ Road in Winter
13 × 17.5 cm (5 × 7 in)

*Step 3: I chose Cobalt Blue, French Ultramarine,
Coeruleum, Raw Umber, Raw Sienna and Cadmium
Orange to paint in the shapes of this abstract work,
paying particular attention to making strong and
interesting tonal relationships.*

STEP 1: Select an image either from life or from a
photograph, then make a small postcard-sized
drawing of it.

STEP 2: Put the photograph or object to one side and
make a second drawing from the first, keeping the
size the same and selecting the shapes you like best.
It is a good idea to turn the image upside down at this
stage in order to help you concentrate on the shapes
rather than the subject.

STEP 3: Select a small range of colours to work with,
and make your choice based on your feelings about
the subject rather than what is there in reality. Fill in
the shapes you have made, concentrating on good
contrasting tonal relationships.

PROJECT

CREATE AN ABSTRACT

- Using newspaper and magazine
 pictures as a starting point,
 make an abstract painting by
 eliminating detail and
 simplifying shapes.
- Ignore the colours that appear
 in the original picture and
 concentrate instead on using a
 small range of pigments that
 express your own feelings about
 the subject.
- As you work on a project such
 as this, a small part of the
 painting may become more
 interesting to you than the
 whole. In this case, isolate
 that area and enlarge it as a
 finished painting.

WASHING-OUT TECHNIQUE

This technique produces some surprising and interesting effects, and is simple to do. The end effect is rather like a lino print, but unlike that method of working it involves no physical cutting.

You will need the following materials:

- Black waterproof ink
- A stiff brush (a small household painting brush will do for the purpose)
- A pointed brush for painting white gouache (it does not have to be small as long as it comes to a point)
- White gouache paint
- Watercolours if you need a soft-coloured 'print'
- Watercolour paper
- A simple motif such as the drawing of Charlie Chaplin that I used.

First make a drawing of your subject on cartridge paper. Trace over it, marking all the black areas. Rub over the underside of the tracing, then lay it on a piece of watercolour paper and draw over the image. Draw a box around the subject to contain the area around it.

Paint in all the white areas with thick white gouache and allow to dry, then cover the whole area with black ink. When the ink is completely dry, put the paper under running water and vigorously brush the image. The areas with white gouache will come away, leaving the image in black.

You can colour the white areas first if you wish by using watercolour before covering with white gouache. The colour will be paler after washing off. Alternatively, you can add colour after the washing off is complete and when the image is dry.

▲ *I began by making a drawing of my subject on cartridge paper.*

▲ *Pressing firmly, I traced over the image. I then rubbed over the underside of the tracing.*

▲ *I laid the tracing on a piece of watercolour paper and drew over the image, including the box around the subject to contain it.*

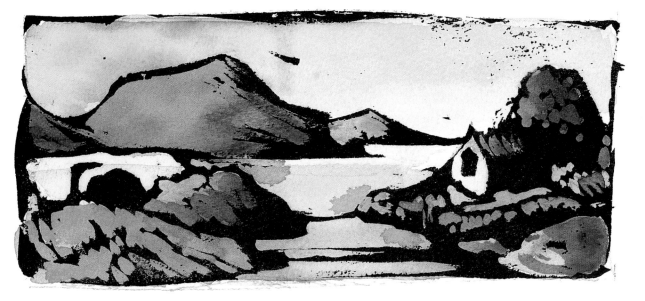

▲ This landscape was produced using the same washing-out method. I added a little colour to the finished image.

▲ Next I painted in all the white areas with thick white gouache and allowed it to dry before covering the whole image with black ink.

▲ The finished image of Charlie Chaplin has the grainy quality of old film.

INDEX